Light of the Spirit

Light of the Spirit

Portraits of Southern Outsider Artists

Karekin Goekjian and Robert Peacock

University Press of Mississippi Jackson

Photographs copyright
© 1998 Karekin Goekjian
Text and compilation
copyright © 1998 Robert Peacock
and Karekin Goekjian
A Silent Fable project

Printed in Hong Kong by C&C Offset Printing Co., Ltd.
Designed by John A. Langston

Library of Congress
Cataloging-in-Publication Data

Goekjian, Karekin, 1949-
 Light of the spirit : portraits of southern
outsider artists / Karekin Goekjian and Robert
Peacock.
 p. cm.
 ISBN 1-57806-025-7 (alk. paper)—ISBN
1-57806-015-X (pbk. : alk. paper)
 1. Outsider art—Southern states.
2. Art, Modern—20th century—Southern
states. I. Peacock, Robert. II. Title.
N6520.G64 1998
 709'.75—dc21 98-6663
 CIP

We would like to acknowledge and thank JoAnne Prichard, John Langston, Dr. Joe B. Massey, Leah Sherman, Roger Gorman, Rick Aguar, Mike Smith, Bill Arnett, Judy McWillie, Melissa Huchinson, Lauren Martinson, George and Virginia Peacock, Annibel Jenkins, Donald Kuspit, Gerard Wertkin, Lee Kogan, Mike Dubois, Kelly Sinclair, Miles Sinclair Dubois, Barbara Archer, Rick Berman, John Denton, Willie Morris, Ginger Goekjian, Michelle Kessler and all the artists who allowed us to catch their spirits before they went to sleep at night.

The Art of Karekin Goekjian
by Donald Kuspit

Like every portraitist, Karekin Goekjian has the difficult task of suggesting the inner life of his subjects by purely external means—through surface, color, composition, and, perhaps above all, the play of light and dark, emblematic of the inner conflicts that are inseparable from being human. Goekjian's task is complicated by the fact that his subjects are artists, indicating that their inner life is particularly rich—that they are more than ordinarily imaginative—and further complicated by the fact that they are self-taught artists, which means not only that they have no formal training, but that they have deliberately gone their own idiosyncratic ways. They are uncategorizable, indeed, radically individual. How can their atypicality be conveyed? Perhaps the only way is to make portraits that are as idiosyncratically imaginative as the artists themselves. Goekjian succeeds in doing so: his images are not the usual set pieces portraits tend to be—the fixed pose for eternity, embalming the subjects in static grandeur and isolating them in immortality—but rather dynamic renderings of the self-taught artists in their private milieus, surrounded by their art.

Goekjian has achieved intimacy and honesty without condescension and, significantly, convinces us that the art accompanying the artist was in fact made by him, that the singularity of the art is a direct reflection of the singularity of the artist and vice versa. This is an unusual achievement: all too often, works of art are shown by themselves, as though they had sprung fully formed from some heaven of the imagination, and artists are shown as sovereign heroes, with no apparent reason—where are their heroic deeds?—why they should be so regarded. Goekjian's artists are not heroes to be blindly worshiped, but ordinary mortals like you and me. Nor are their works miraculously self-sufficient, as though they belonged in the hereafter of some museum of the mind rather than here on earth.

Goekjian's portraits show great insight: he makes it clear that the works of the self-taught artists are part of their lived experience, and as such experientially alive. He ends the bifurcation between the life of the artist and his or her art, demonstrating a direct connection, indeed, inseparability. Whereas in the usual approach it is assumed that artists rise

above themselves by making art—that the work of art ultimately stands on its transcendental own, independent of the artist's life experience—here Goekjian makes it clear that the work of art shows how embedded the artist is in his lifeworld, and reveals what is most inherent and inescapable in it, and thus in himself. The work is not an autonomous object but is concretely, and daringly, human.

Goekjian's artists learned their art in the school of life, that of the rural South. The pine tree against which one of the Reverend John D. Ruth's sign-works rests belongs to this earthly old communal South, as does the way he kneels on the ground next to it. So does the fantastic cross-covered tree, crawling with cast-off artifacts—so-called junk—in the photograph of Vollis Simpson. Similarly, Lonnie Holley and his enigmatic sculptures are placed in a natural setting (traditionally, many people lived outdoors as much as indoors in the South) with a dark old kerosene lantern from the preelectric past. The artistic use of old materials, which have lain around long enough to seem pieces of nature, is strikingly evident in Ronald Lockett's expressionistic grid, a freestanding abstract structure that is as organically alive and archetypal in import as are Simpson's tree and crosses. All these artists' works add resonance to their environment, making a kind of "natural community," even as they resonate with its inner meaning.

They have created and live in a world of fantasy which refuses reality, and with good reason: life would be denuded, having little to show, without fantasy to keep it going. For all these artists, black and white, are poor, and they make art to enrich their homes; much of it is figurative, and many of the figures are in effect gods of the hearth—apotropaic symbols, warding off hidden evil, which is certainly what the bright figure above R. A. Miller seems to be doing. The giant mask behind which Benny Carter stands (he is visible in its left eye) seems to accomplish this, as the dragon-spirit that is crawling—being cast?—out of the right eye suggests. The bright color of Carter's works, strikingly evident in a second photograph, and their animistic totemic character confirm their protective nature as house-

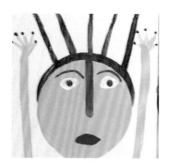

hold gods. Jimmy Lee Suddeth's paintings of the chickens he sees every day are also acts of animistic homage that convert them into spiritual presences, guarding his home.

Clyde Jones's carvings (forest creatures, clearly of the night, as their glowing, devilish eyes suggest) and paintings (giant turtles and strange fish, creatures able to fathom the depths and be at ease there) serve the same function, as do the white crosses in a black field where W. C. Rice is standing and the necklace with a carved crucifixion of Christ that he wears. Again and again the self-taught artists stage an elemental conflict between good and evil, the forces of light and darkness. Harold Rittenberry's remarkable metal horse, with a mane of rusted chains, is a devil in disguise—recall that in the Bible death comes on a pale horse—and the angelic figures appearing in a second photograph of him dance in an undersea heaven. Certainly the photograph of the luminous figure of Howard Finster in the darkness of his home, or standing in heathen nature, bespeaks that conflict. Similarly, Thornton Dial, Sr., stands alone in the dark, protected and sanctified by his art as by a halo. Both artists are the embodiment of goodness and light, proudly holding their own against darkness and emptiness. Like the communities in which they are rooted, they have a strong sense of identity and an unshakable integrity.

In general, Goekjian creates dramatic contrasts of light and dark which heighten the artist's appearance psychologically as well as reflecting his and his community's fundamental concerns. At the same time, color is extraordinarily vivid in these photographs, as animistically alive and elemental as the work of the artists. The interplay of chiaroscuro and color deepens the magic of the image. Goekjian's photographic art has an intensity that holds its own with the self-taught art. His photographs have the same aura of direct yet enigmatic statement, conveying the same sense of urgent abstraction and moral emergency. His portraits achieve a rare empathy with their subjects.

Authentic Voices, Stammered Words

by Gerard C. Wertkin

I f *Light of the Spirit: Portraits of Southern Outsider Artists* had been published just a few years ago, its subtitle would almost certainly have been different. The subjects of Karekin Goekjian's compelling portraits, which are presented in this handsome volume, would have been described as "southern folk artists" rather than as "outsiders." As confusing as this may seem, the reasons for such a radical change in terminology, if not in perception, may actually shed some light on the nature of the creative expression of the artists represented in this book. I therefore intend in this brief essay to trace the sources of the two terms, consider shifts in their usage, and suggest that neither provides a sufficiently nuanced context in which to understand a still uncertain but fascinating esthetic terrain.

Until recently, contemporary or twentieth-century "folk art" was the term most commonly encountered in this field, and its use had been affirmed in the titles of scores of museum exhibitions and publications. It was chosen, for example, by Jane Livingston and John Beardsley for *Black Folk Art in America, 1930–1980*, their groundbreaking exhibition at the Corcoran Gallery of Art in 1982, even though they recognized that the artwork assembled for the presentation was not, strictly speaking, "folk"—that is, directly dependent on inherited traditions or forms.

As considered in Livingston's and Beardsley's exhibition, "folk art" did not imply crafts or traditional utilitarian artisanship, pursuits often associated with the expression, but rather full-fledged "gratuitous" works of art—paintings, drawings, and sculptures—reflecting "an esthetic paradoxically based in a deeply communal culture, while springing from the hands of a relatively few, physically isolated, individuals."[1] Although the artists were "generally untutored," at least in terms of academic education, they were "masterfully adept, displaying a grasp of formal issues so consistent and so formidable that it can be neither unselfconscious nor accidentally achieved."[2] It was in this sense that the term "folk art" had been used for many years by those working in the field of fine arts in the United States, following the model suggested by Herbert Waide Hemphill, Jr., in *Twentieth-Century American Folk Art and Artists*, an exhibition with wide-ranging parameters and influence, which he presented in 1970 at the Museum of American Folk Art in New York.

Although Hemphill and others recognized inadequacies in this usage,[3] it continued to enjoy broad-based institutional and popular acceptance in the United States. Among the significant museum presentations that helped sustain and validate the approach implied by the term were *Missing Pieces: Georgia Folk Art, 1770–1976* (Atlanta Historical Society, 1976), *American Folk Art: The Herbert Waide Hemphill, Jr., Collection* (Milwaukee Art Museum, 1981), *Muffled Voices: Folk Artists in Contemporary America* (Museum of American Folk Art at Paine Webber Art Gallery, 1986), *Outside the Main Stream: Folk Art in Our Time* (High Museum of Art, 1988), *Made with Passion: The Hemphill Folk Art Collection* (National Museum of American Art, 1990–91), and, more recently, *A World of Their Own: Twentieth-Century American Folk Art* (The Newark Museum, 1995). Notwithstanding this impressive chronology, to which other examples justifiably might be added, there was a growing frustration with the approach among critics in the field that often was expressed in lively debate in exhibition catalogs and essays. The paintings, sculpture, and built environments of twentieth-century self-taught artists continued to be contextualized as folk art, although often begrudgingly. The source of this disaffection may be found in the genesis of the term "folk art" itself, in the varying discipline-based meanings assigned to it, and in the divergent classes of cultural production comprehended by its usage in Europe, where the expression originated, and in the United States, where it developed along very different lines.

Among European ethnographers and art historians, "folk art" is a class-based concept, referring almost invariably to the tradition-bound household crafts of peasant communities—ceramic vessels, woodcarvings, woven and embroidered textiles, local or regional costume, and hosts of other objects of utility, ceremony, personal ornament, or home decoration. According to this view, which found fertile soil in the romantic nationalism of nineteenth-century Europe, *Volkskunst* is profoundly conservative in nature, drawing deeply from the wellsprings of rural culture—a culture that is seen as the authentic soul of the nation. As such, folk art is transmitted through successive generations within closed

groups that generally are related by kinship, common agrarian life patterns, and religious faith. Although this understanding of folk art emphasizes received forms and conventions, it does not devalue the individual hand or intentions of the creator; on the contrary, technical virtuosity and personal esthetic choices are celebrated, it being recognized that without these contributions community traditions would stagnate and die.

Ironically, it was in the late nineteenth century, at the very time when European folk art was first being systematically collected and studied by the Swede Artur Hazelius and other pioneers, that the production of these traditional crafts began to wane, principally as the result of changing social conditions, industrialization, emigration, and the consequent loss of village life.

In the United States, the collecting of folk art began in the 1920s and 1930s independently of the earlier European interest in the subject. From the start it took a radically different direction, at least in part because the social conditions supporting the creation of folk art in Europe did not exist in America, except in relatively closed communities with fully integrated cultural traditions, generally ethnic in nature—like the region of southeastern Pennsylvania settled by Germans in the eighteenth and nineteenth centuries or the Hispanic villages in northern New Mexico of the same period. To be sure, European ideas about folk art continued to affect American thinking on the subject, especially in the academic disciplines of folklore, folklife studies, and cultural anthropology. But many Americans came to know the field through museum presentations that were organized around an entirely different perspective, one defined by Holger Cahill, curator of several of the first exhibitions devoted to the subject in the United States. In a 1931 essay in *The American Mercury,* Cahill demonstrated how different his conception of the subject was from the earlier, European ideas. "Folk art as here considered," he wrote, "does not include the work of craftsmen—makers of furniture, pottery, textiles, glass, and silverware—but only that folk expression which comes under the head of the fine arts—painting and sculpture. By folk art is meant art which is produced by people who have little book learning in art techniques

and no academic training, whose work is not related to established schools. . . . "[4] It is worth noting that these ideas continued to resonate in the approach taken by Livingston and Beardsley fifty years later. This is not to suggest, however, that such creative endeavors were not without substantial esthetic merit. "Much of it," Cahill observed, "was made by men who were artists by nature, if not by training, and everything they had to say in painting and sculpture is interesting. Theirs is often a stammered beauty—but it is beauty."[5]

Holger Cahill's *American Primitives: An Exhibit of the Paintings of Nineteenth Century Folk Artists* (The Newark Museum, 1930–31), *American Folk Sculpture: The Work of Eighteenth and Nineteenth Century Craftsmen* (The Newark Museum, 1931–32), and *American Folk Art: The Art of the Common Man in America, 1750–1900* (The Museum of Modern Art, 1932) established a pattern that would influence American thinking on the subject through the end of the twentieth century. In one sense, however, Cahill and the Europeans agreed. For the most part, they reasoned, folk art was a thing of the past. In fact, Hemphill's use of the term in 1970 to describe contemporary self-taught artists was a major departure from much prior thinking on the subject.

It should be acknowledged here that neither Cahill nor the early collectors of American folk art ever articulated clear or comprehensive parameters for the field that they had established nor did they attempt to understand folk art in the context in which it was created. Many of these collectors were themselves artists who were seeking, in the years following the 1913 Armory Show, a paradigm for a new American art, with freedom from the conventions of the academy. For these modernists, folk art represented something of the spirit of America itself—a romantic notion remarkably similar to European sentiments about *Volkskunst*. Elie Nadelman, Yasuo Kuniyoshi, Marsden Hartley, William Zorach, Robert Laurent, and Charles Sheeler were among the important American artists whose work was influenced by their exposure to folk art. As opposed to the art of the academy, folk art was seen as direct, simple, free from the constraints and posturing of academic

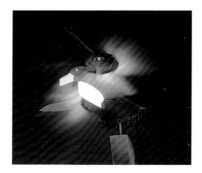

realism, and, above all, authentic. Indeed, much of this interest in folk art may be seen as a quest for authenticity, an effort to recover something primal deemed lost in social conventions and cultural forms, a quest that was not confined to the United States. Kandinsky and the *Blaue Reiter* artists, Kirchner and the *Brücke* group—and all the modernist movements that expressed a debt to primitivism—helped foster appreciation for folk art during the early twentieth century.

If the interest in folk art in the United States began in the 1920s and 1930s, it would not be until later in the century that a closely related field of interest would develop in the work of artists creating outside the mainstream. *Outsider Art* was the name Roger Cardinal gave to his 1972 study of *art brut*, a concept that "embraces not only the art of the clinically insane but also other art of an authentically untutored, original, and extra-cultural nature."[6] This category of artistic expression was originated by Jean Dubuffet, who founded the *Compagnie de l'Art Brut* in France in 1948. For Dubuffet, mainstream art had become a repetitive cultural exercise. He saw in *art brut*—in "outsider art"—an unmediated expression of creativity: spontaneous, raw, and uncompromising. "We mean . . . the works executed by people untouched by artistic culture," he wrote, "works in which imitation—contrary to what occurs among intellectuals—has little or no part, so that the makers derive everything (subjects, choice of materials used, means of transposition, rhythms, patterning) from their own resources and not from the conventions of classic art. . . ."[7] Since folk art was associated with tradition and community, at least in the original, European sense of the term, *art brut* would seem to stand in stark opposition to it.

Although it is difficult to imagine the use of two such dissonant terms to describe the same artists and their work, this is precisely what began to occur in the United States over the last two decades. The two terms, after all, did share some similarities in meaning; as expressions they were less parallel in nature than convergent. As we have seen, both were concerned with art created outside the institutional structure of the art world by individuals without academic training. "Outsider art" had the advantages of its relative newness as

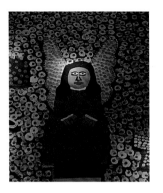

a term and the fact that it did not carry a history of varying usage. The Museum of Contemporary Art in Chicago presented *Outsider Art in Chicago* in 1979–80, including works that previously had been contextualized as folk art; the two terms were brought together in *Pioneers in Paradise: Folk and Outsider Artists of the West Coast* at the Long Beach Museum of Art in 1984–85. *Signs and Wonders: Outsider Art inside North Carolina* was presented by the North Carolina Museum of Art in 1989, and *Parallel Visions: Modern Artists and Outsider Art* was organized by the Los Angeles Museum of Art in 1992. *Parallel Visions*, incidentally, demonstrated that a new generation of "mainstream" artists was being influenced by creativity in the esthetic terrain that is being discussed here.

This is not to suggest that distinctions are not being drawn between folk art and outsider art. Rather than clarifying matters, however, the distinctions often are drawn at the expense of the older term: "folk art" is defined according to the more specific, more limiting European criteria discussed in this essay, but it is also stigmatized as static, shallow, and derivative. Authenticity and esthetic strength are claimed to reside solely in the artworks of persons living at the margins of society, especially those afflicted with mental illness. While it is undoubtedly true that passion and power may be found in abundance among "outsiders," these virtues are no less in evidence among artists who draw from the traditions of community. Too often the proponents of outsider art, it seems to me, are unwilling to recognize the importance of cultural contexts. In fact, when the surface is scratched, the full complexity of each artist and of his or her work becomes apparent. Facile and narrow labels that reduce the creative spirit to a single dimension are of little significance in the long run, especially when they obscure the multiplicity of intentions, ideas, meanings, influences, connections, and references inherent in every work of art. The Georgia artist Howard Finster, for example, whom Goekjian has photographed for this volume, cannot be understood fully except within the context of southern evangelical religion. His work is replete with images drawn from biblical narrative and the popular piety of a thousand southern road signs. Finster's language is prophetic and apocalyptic, and he

sings the hymns and recites the prayers of the churches of rural Georgia, but he is profoundly idiosyncratic in his interpretation and expression of these folkways. It would be a mistake to assume that Finster's artwork can be perceived as outside tradition; he is a cultural "insider." But there was nothing quite like his Paradise Garden elsewhere in north Georgia, and his paintings, sculptures, and assemblages bespeak private visions and inner messages as well as evangelical fervor.

In Karekin Goekjian's photographs, we are invited to meet a group of southern artists through the eyes of an artist, but we must not be lured into the belief that we can really *know* them through the pages of a book or through labels that speak more to perceived or imagined status than to individual accomplishment. Other terms have been suggested: "intuitive," "isolate," and "visionary," for example, but each fails to take into account the artist's work in its full dimensions. The categories, in each case, give way to the art, however deeply rooted in culture it may be, or idiosyncratic in expression. In one sense, the proponents of "folk art" and "outsider art" have it right. The art of the gifted individuals presented here is authentic. It is only our words that are stammered.

1. Jane Livingston and John Beardsley, *Black Folk Art in America, 1930–1980* (Jackson: University Press of Mississippi, 1982), 11.

2. Ibid.

3. Herbert W. Hemphill, Jr., and Julia Weissman, *Twentieth-Century American Folk Art and Artists* (New York: H. P. Dutton & Co., Inc., 1974), 11.

4. Holger Cahill, "American Folk Art," *The American Mercury* 24 (September 1931): 39.

5. Ibid., 46.

6. Roger Cardinal, *Outsider Art* (New York: Praeger Publishers, 1972), 24.

7. Jean Dubuffet, quoted in Michel Thevoz, *Art Brut* (Geneva: Skira, 1976), 9.

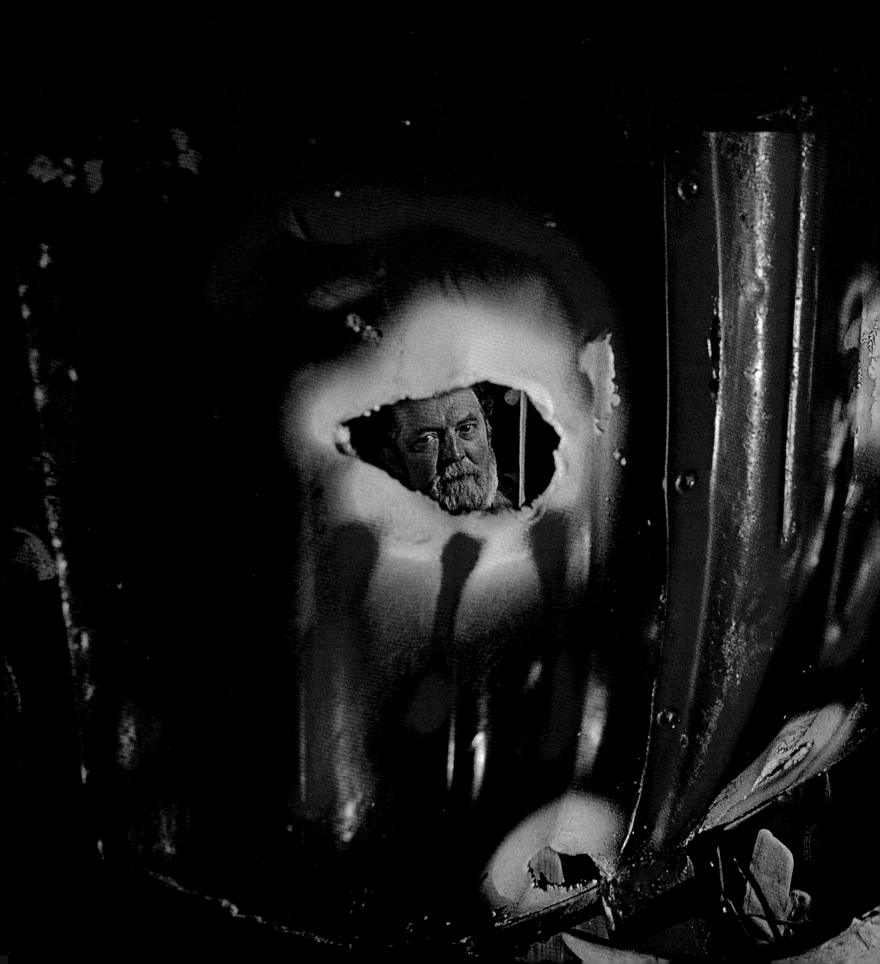

I am obsessed with painting. I paint anywhere from sixteen to twenty hours a day, seven days a week. I got up this morning at two o'clock. I'm just obsessed with it; I don't know why. When a new idea comes along, I just can't wait until I get the painting to a certain point. I might not finish it right then; sometimes I work a year on a painting. Sometimes I work on ten or fifteen paintings at one time. Most everything I do takes a week or two.

Why do I make art? I don't know why I do art. For fifteen years of my life I wouldn't give you two cents for all the art on earth. I didn't even finger paint when I was in school.

Benny Carter

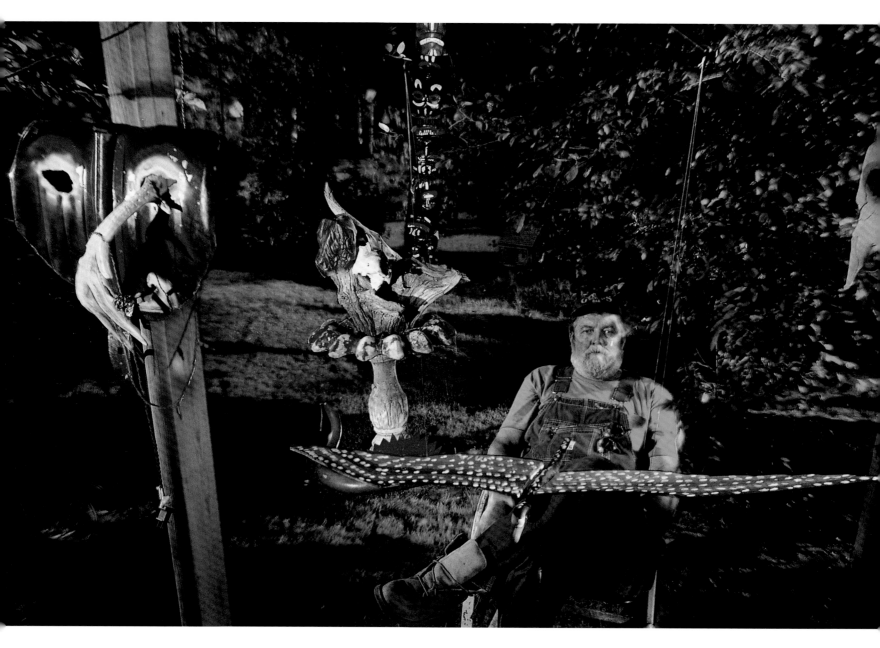

Benny Carter

Born in Highpoint, South Carolina, 1943.
Resides in Madison, North Carolina.

Carter grew up in North Carolina. After fin-
ishing high school, he worked for the A & P
grocery store chain, and later at Halstead
Metal Products, a producer of copper refriger-

ator tubing, where he cleaned and rebuilt the
production machinery. When he was laid off
from work in 1990, he began making art full
time.

Obsessed with painting, Carter sometimes
works twenty hours a day, waking up early in
the morning and continuing late into the night.

Using enamel-based house paint, he has cre-
ated a large body of work depicting biblical
themes, the Ku Klux Klan, and a variety of
cityscapes. Primarily a painter, Carter also cre-
ates musical instruments, furniture, birdhouses,
whirligigs, model ships, and various kinds of
carvings.

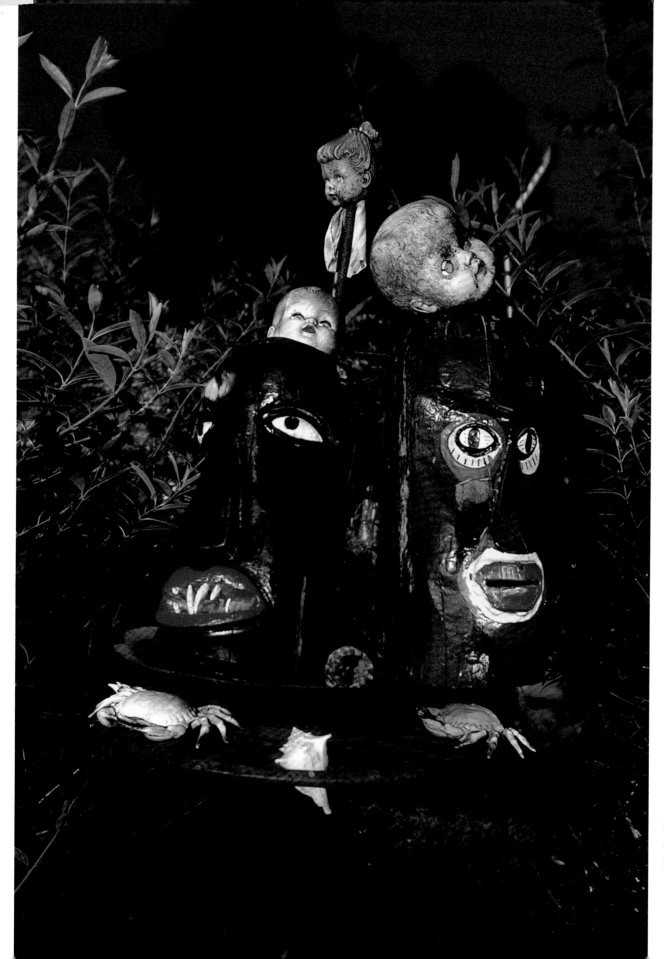

Sculpture, found
object and mixed
media construction

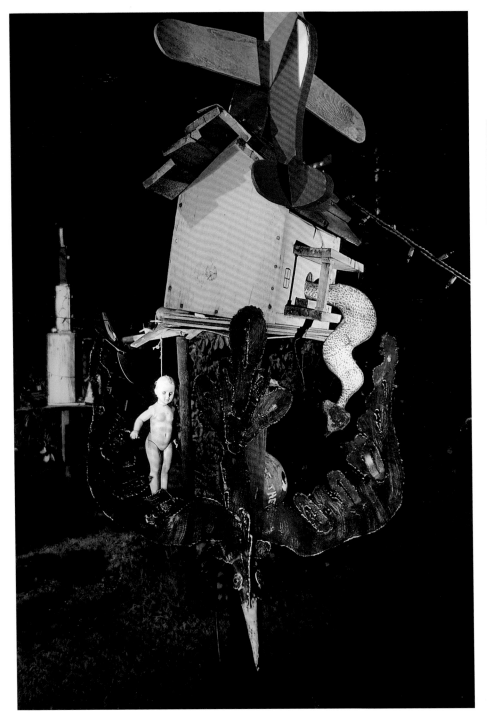

Backyard birdhouse,
found objects, wood
and paint

Backyard sculpture,
welded metal and
paint

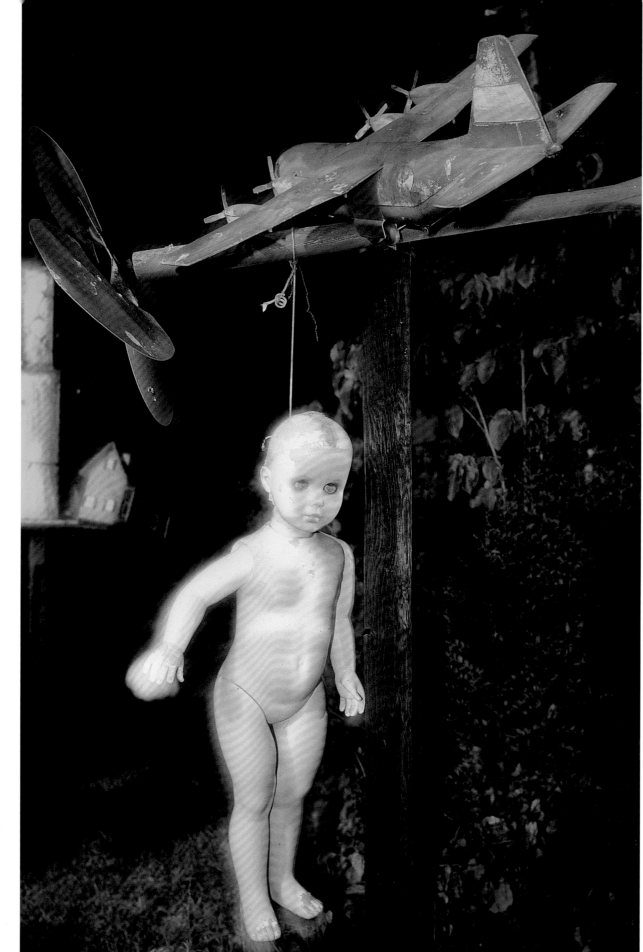

Airplane and doll
whirligig, found object
and mixed media con-
struction

Thornton Dial, Sr.

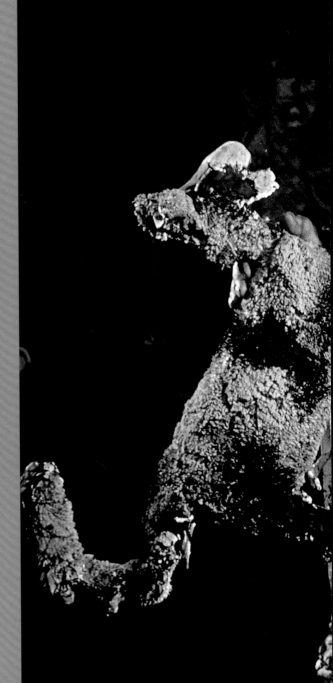

My artwork is about the struggle of life, a way of life, and that way of life is a struggle. We all have struggles and work to do. I have watched things all my life, since I've been big enough to watch things and pay attention about life. Life to me is about coming together.

I've always wanted to do things. I wanted to be as much as anybody else. This has been me all my life and I have made things about that.

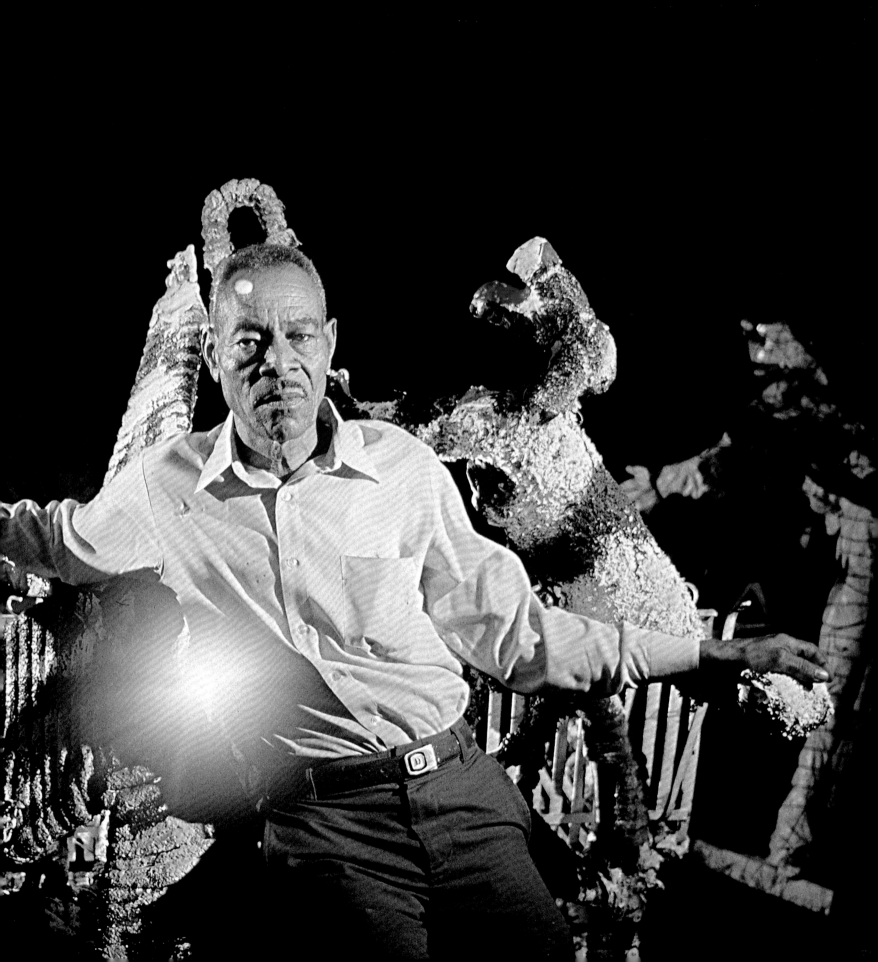

Thornton Dial, Sr.

Born in Emmel, Alabama, 1928.

Resides in Bessemer, Alabama.

Dial began working at a very young age. Serving alternately as a carpenter, iron worker, and house painter, he also worked between 1952 and 1980 as a laborer for the Pullman Standard Railroad Company. In 1984, he and his two sons went into business building and selling wrought-iron lawn and patio furniture. He devoted his spare time to making sculpture, paintings, and object assemblages. In 1987 he began to create art full time.

Dial's work, in which he uses a variety of materials and found objects, ranges from large, mixed-media paintings and sculpture to more intimate drawings and watercolors. He is perhaps best known as a painter; his striking creations focus on contemporary social and political issues, including the complexities of class, race, and gender relations. Dial's insightful social commentary and powerful rendering of subjects through the expressionistic use of paint and texture have made him one of the best-known self-taught artists in the United States.

Painting, metal, acrylic paint on canvas

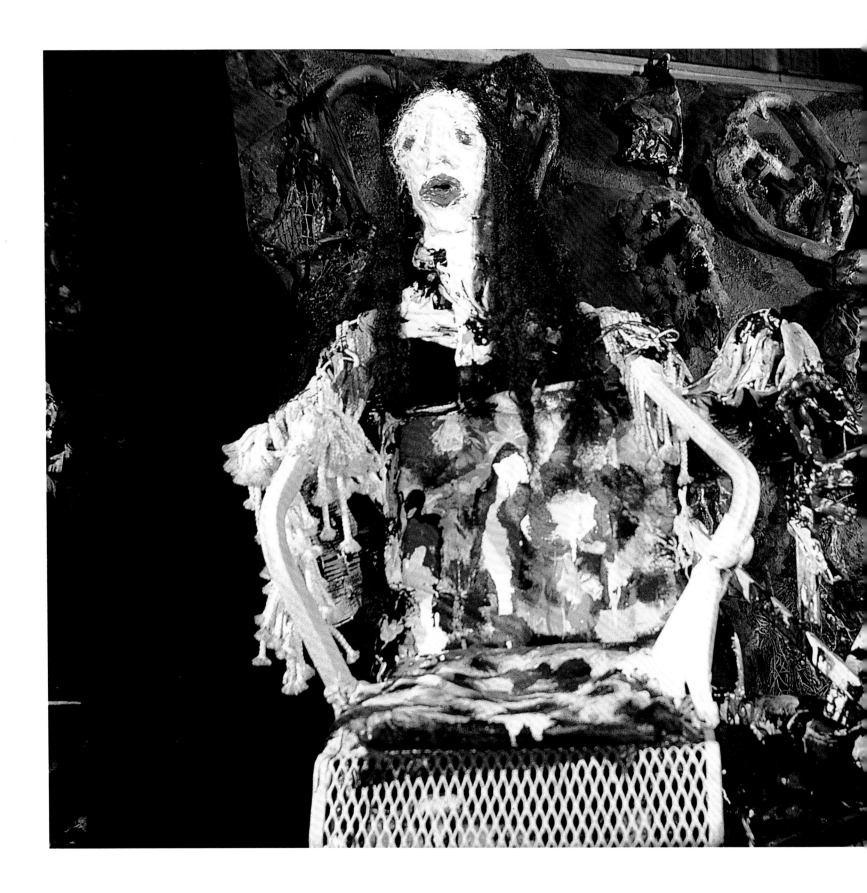

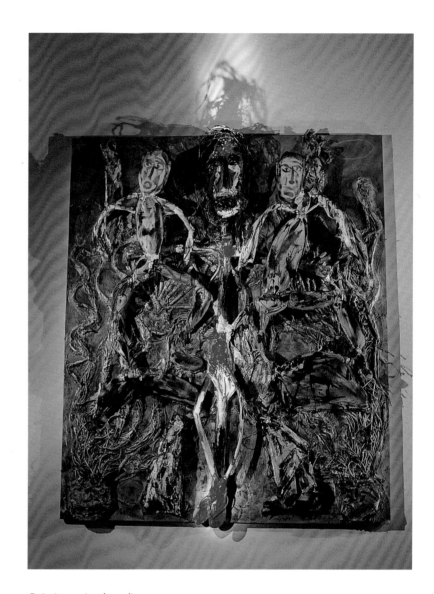

Painting, mixed media
on canvas

Chair sculpture, mixed
media construction

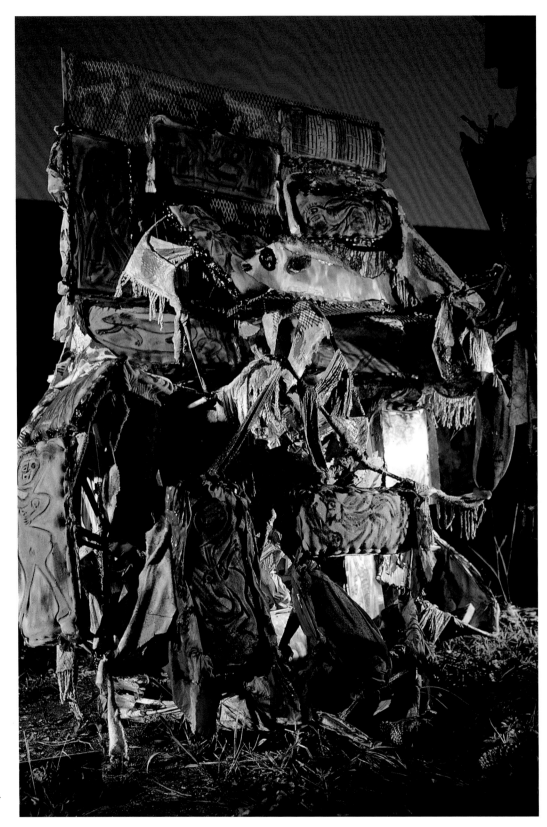

Backyard sculpture,
mixed media construc-
tion

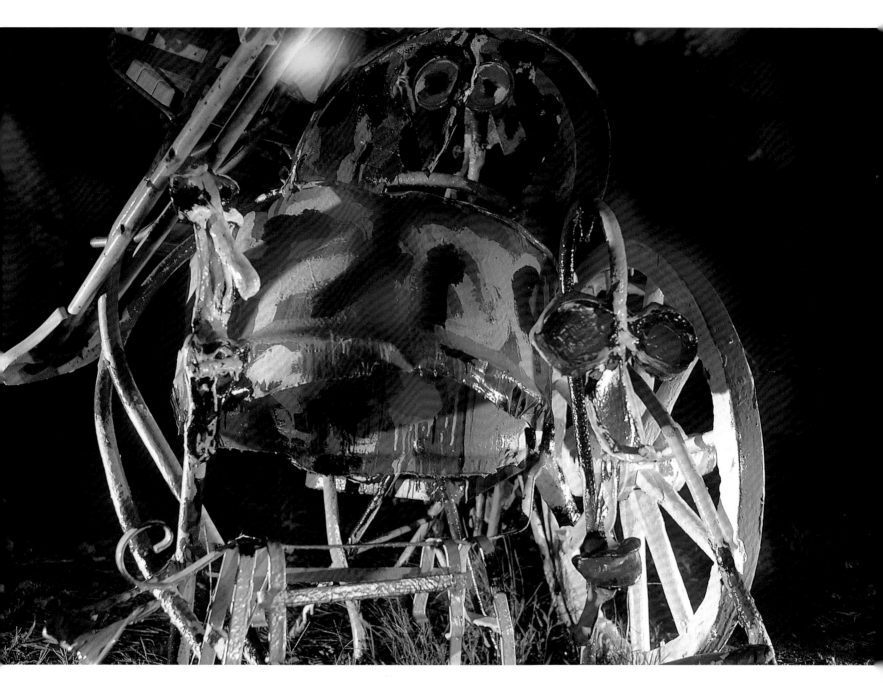

Sculpture, mixed
media construction

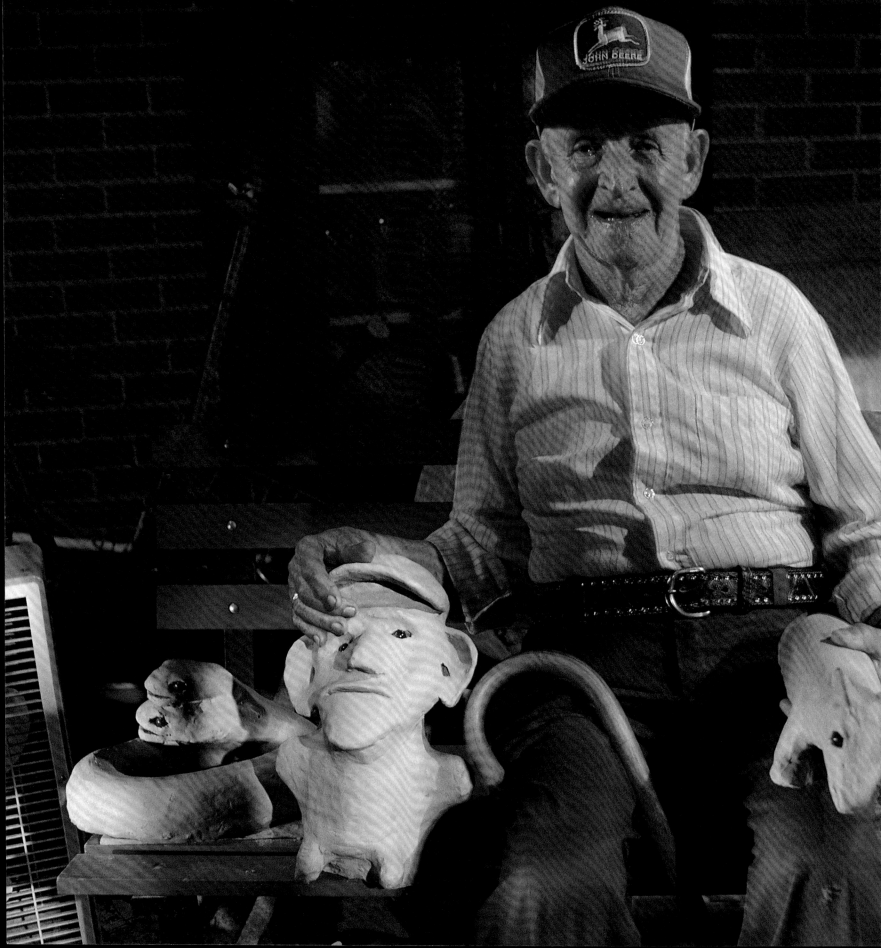

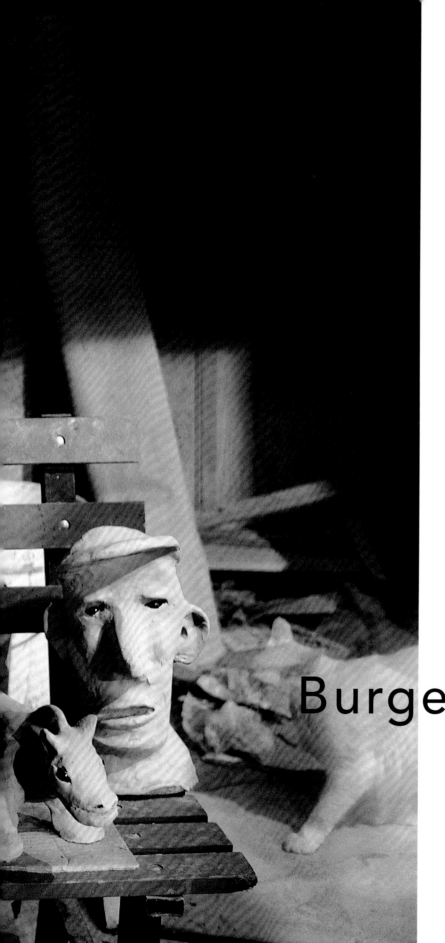

I always liked to play with mud.

I guess I never growed up.

Burgess Dulaney

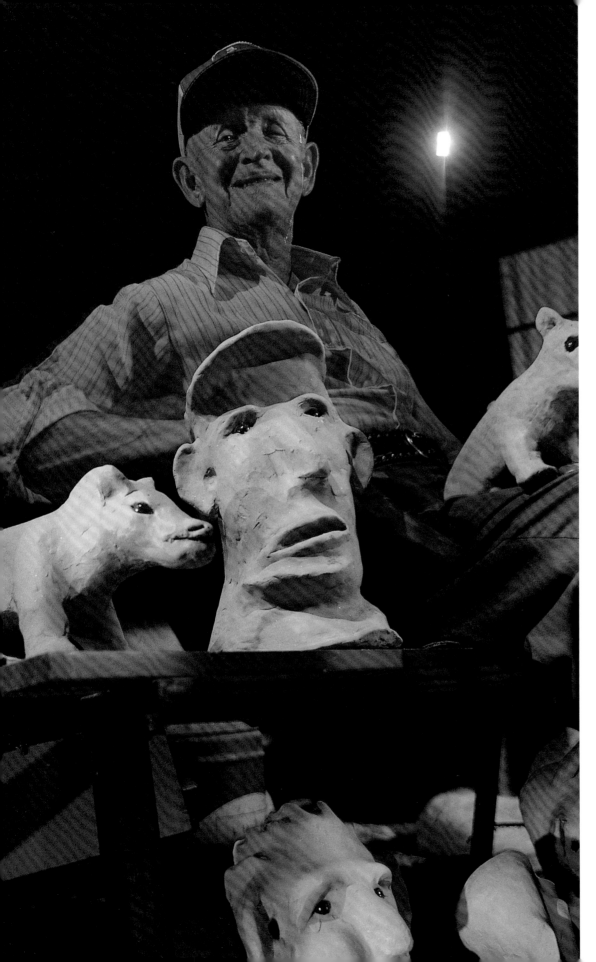

Burgess Dulaney

Born in Itawamba, Mississippi, 1914.
Resides in Fulton, Mississippi.

Dulaney never attended school and is unable to read or write. He spent most of his life working on the family farm in north Mississippi. He began working with clay over twenty-five years ago, creating an assortment of animal forms which he says were inspired by the television program *Wild Kingdom*.

Dulaney's renderings of lizards, bears, eagles, antelopes, and snakes are constructed on boards and then left in a shady place and allowed to dry slowly. In addition to his animal figures, Dulaney has created human figures that resemble pre-Columbian artifacts. Paint is sometimes later applied to the work. Dulaney has also occasionally made pieces out of cement, although he is best known for his clay work.

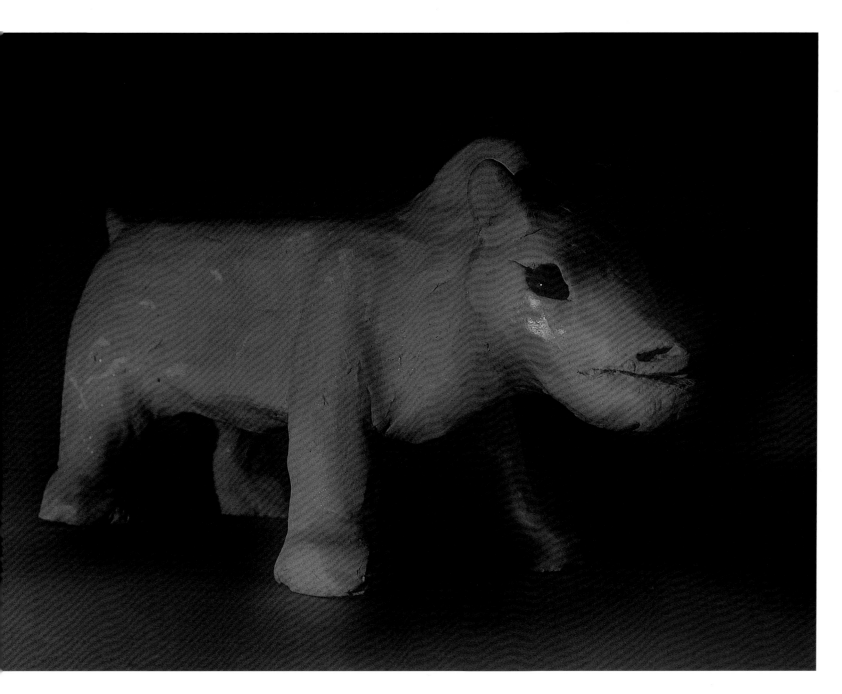

Animal sculpture,
unfired clay

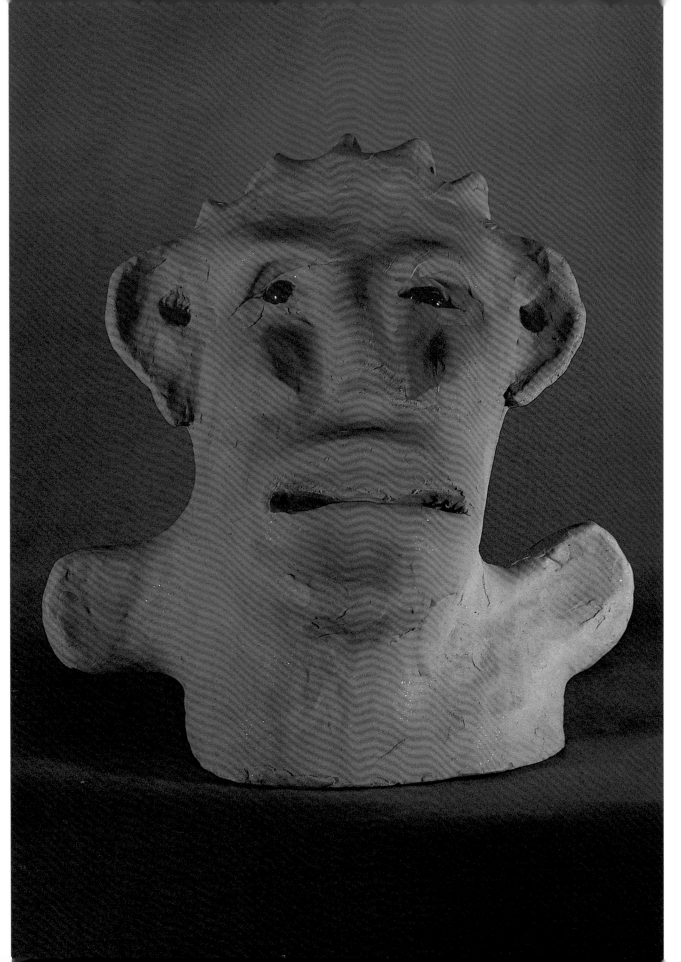

Face sculpture,
unfired clay

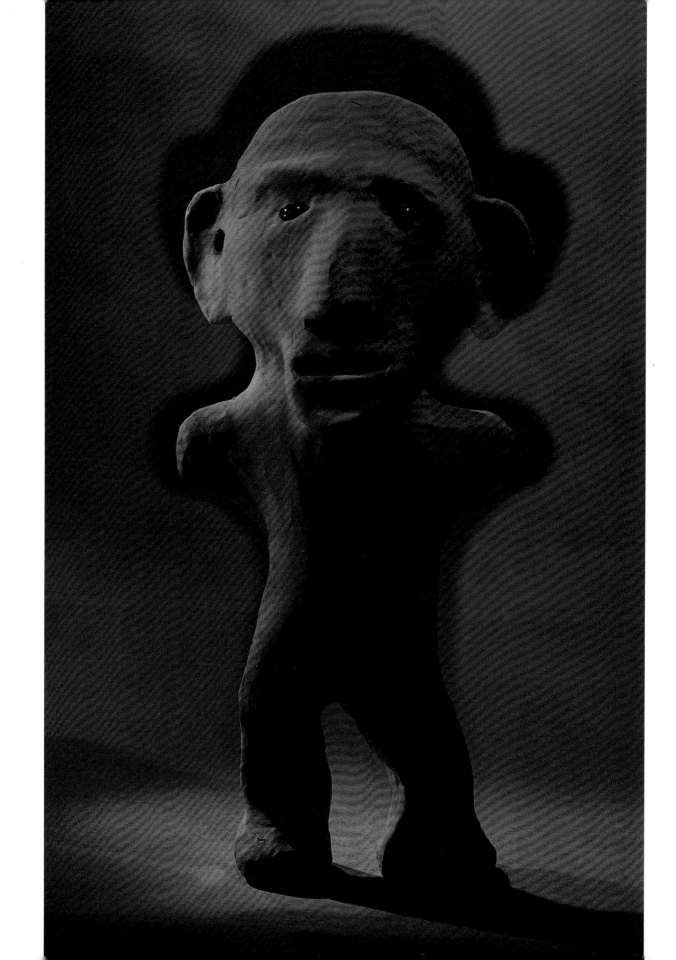

Human figure,
unfired clay

Howard Finster is a second Noah, to reach the world, before it is too late. I am having more success in a way than Noah had. The first Noah preached to the world; he didn't get a one of them saved. This is what I am all about here trying to get peace in the world and get the world a thousand more years, to live here. If we don't, the way this world is traveling at least it will be corrupt, and so a human can't live on it. And fifty more years, if it keeps going down like it has in the last fifty years, it won't be a fit place for nobody to live, animals or anything. Fish are not destroying the world, birds are not destroying the world, the wild animals in Africa are not destroying the world—it is human beings, it is people destroying the world on which they live on. My God, people, wake up, we got to get this world to come together—neighbors to come together, cities to come together, so we can live a little bit before we die.

My life here on earth is to give to the people. I was sent here for the people, not for myself. If I had been sent here for myself, I'd been hunting and fishing like a lot of you all. I'd sit in the stadium and watch my grandkids play football. I'd go to the movies and just enjoy this life, if I were here just for Howard Finster. But in case you don't understand, I'm here for you.

Howard Finster

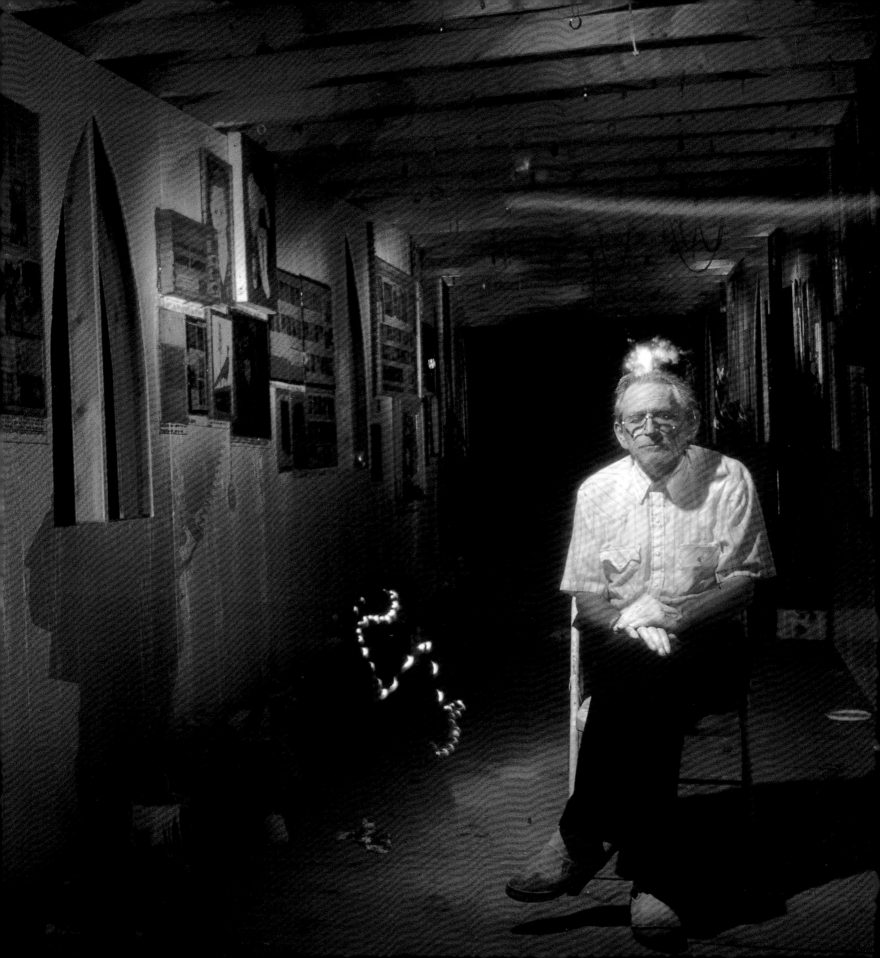

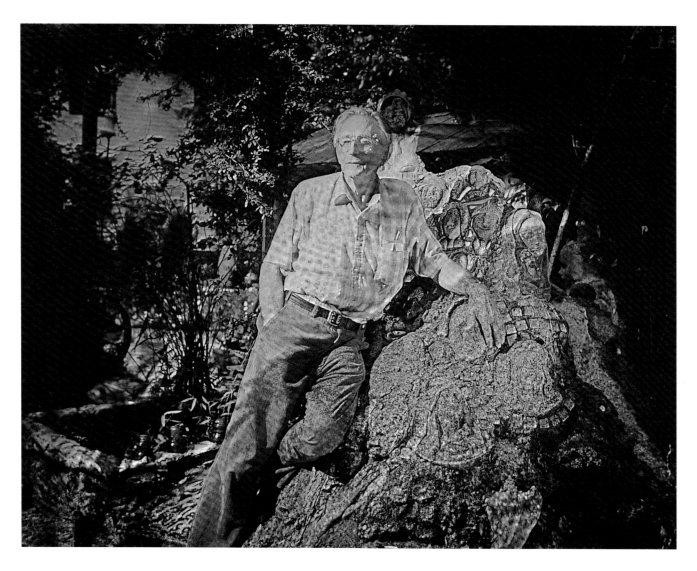

Howard Finster

Born in Valley Head, Alabama, 1916. Resides in Summerville, Georgia.

Finster, who has been a farmer and a preacher, has spent the past twenty-five years working on his great creation, Paradise Garden, in Summerville, Georgia. Neighbors and townspeople brought all of their discarded items and junk, and, with these materials, Finster began creating sculptures, buildings, and mirrored pathways to wind among the fruit trees he planted and the streams he made. The garden is filled with signs that describe his intentions as an artist: "I took the pieces you threw away and put them together by night, and day washed by rain, dried by sun, a million pieces all in one." "Old men have dreams, young men have visions." And, everywhere, he has peopled the garden with images of his heroes: Henry Ford, Hank Williams, Shakespeare, George Washington, John Kennedy, John the Baptist, and Elvis Presley. This ever-changing environment is a shrine to human creativity.

Finster has created over thirty-six thousand paintings and sculptures, his intent being to bring all the people in the world together, and, despite his deteriorating health, he still makes artwork daily. His paintings can be found in the permanent holdings of the Smithsonian Institution, as well as in many other museums and private collections.

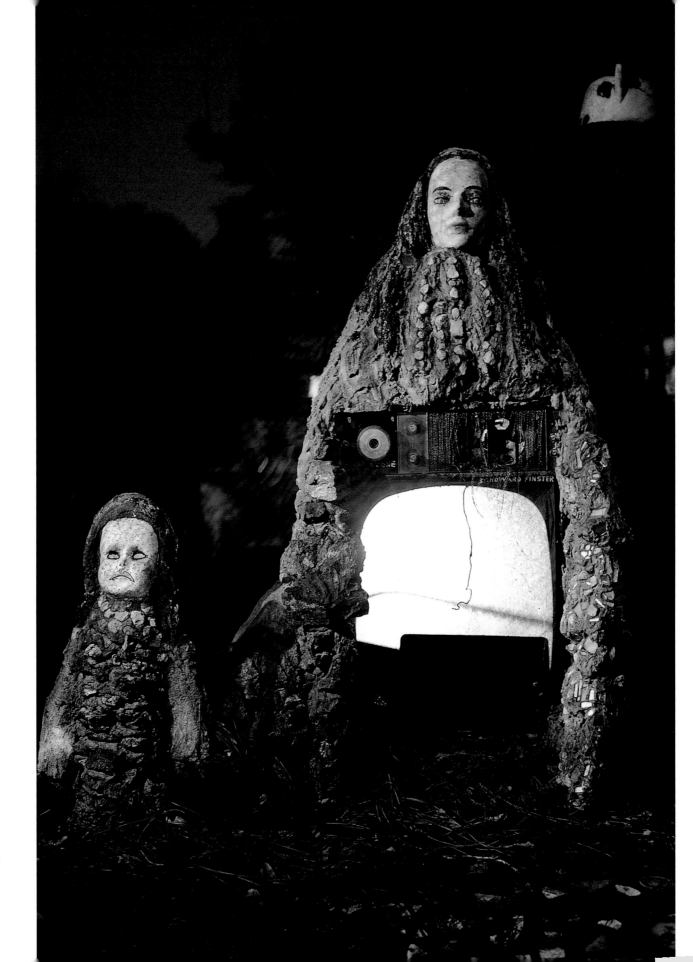

Woman and child
sculpture, mixed
media construction

Folk art chapel,
Paradise Garden

Paradise Garden

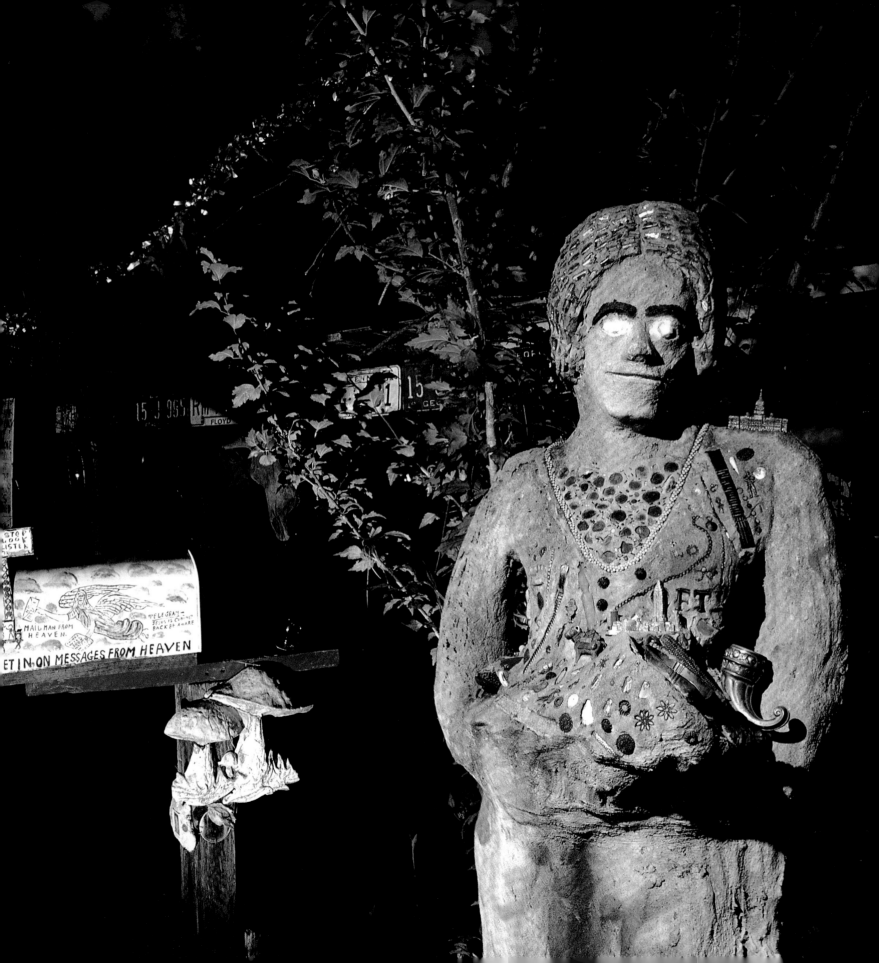

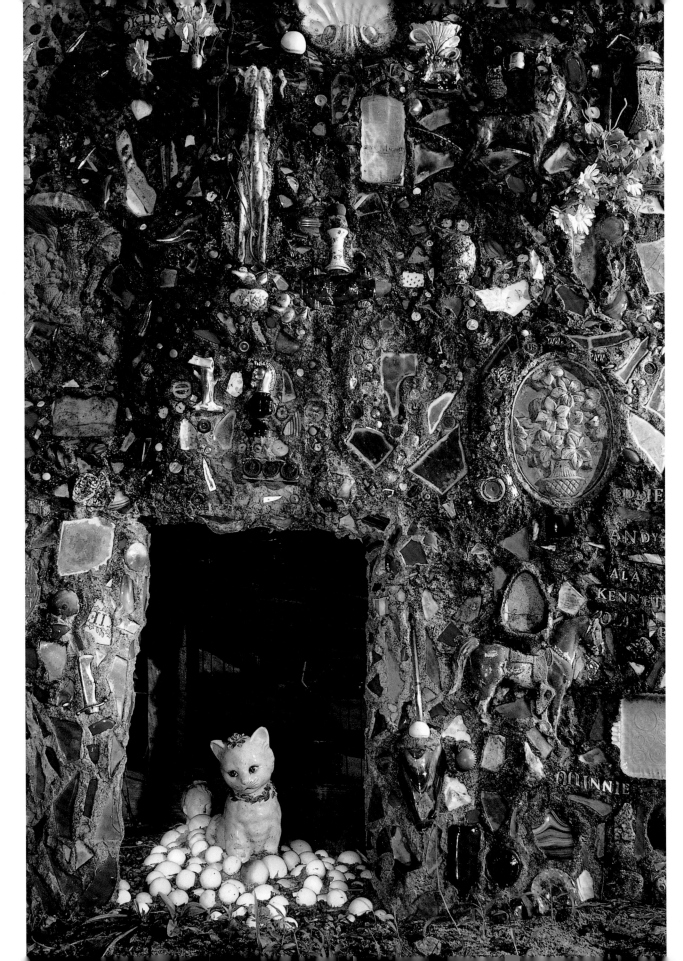

Wall molding, cement
and found object

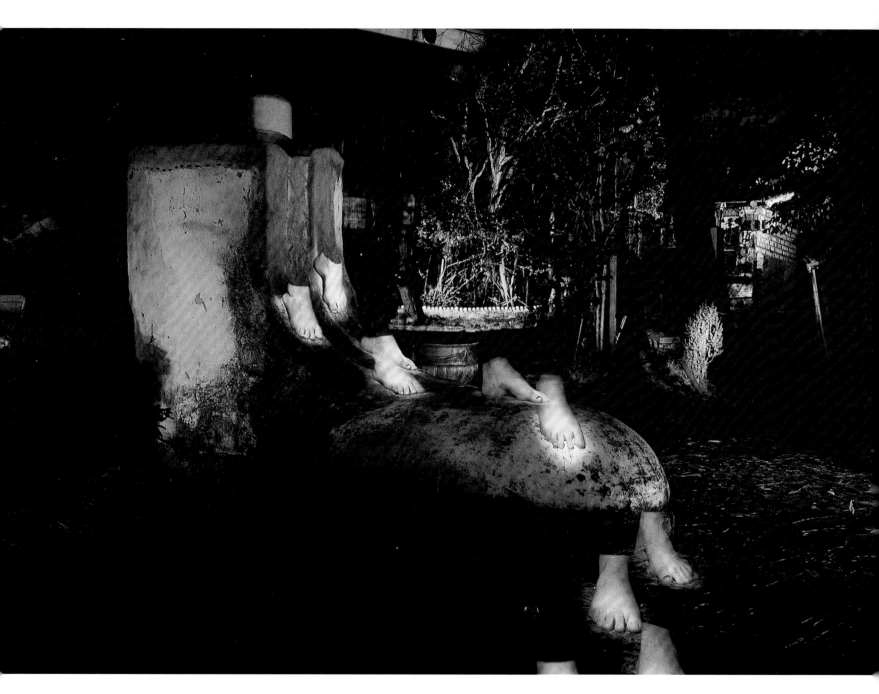

The Giant Shoe,
cement and brick
molding

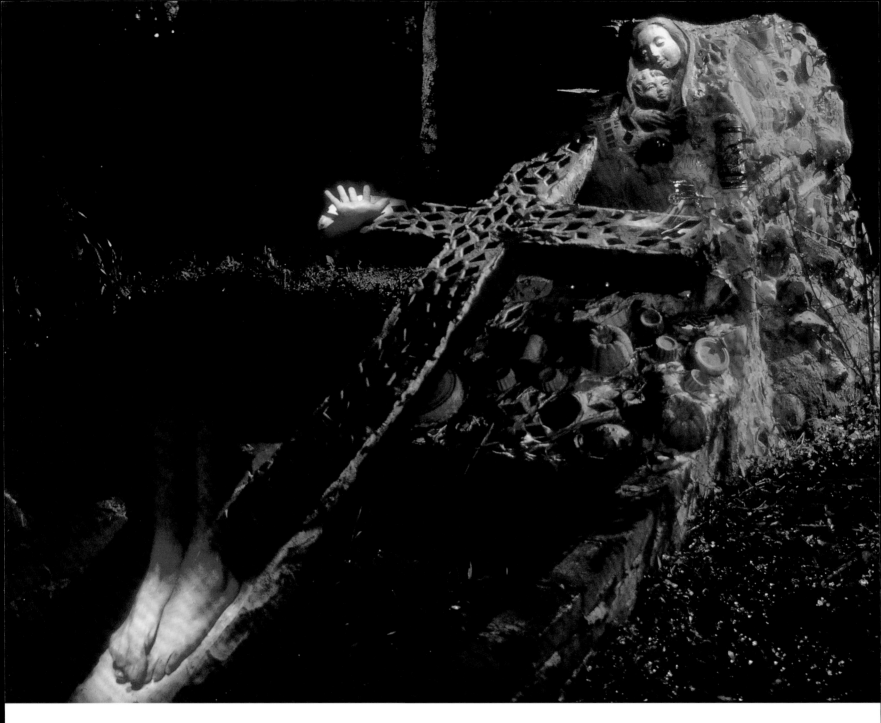

Cross, mixed media
construction, Paradise
Garden

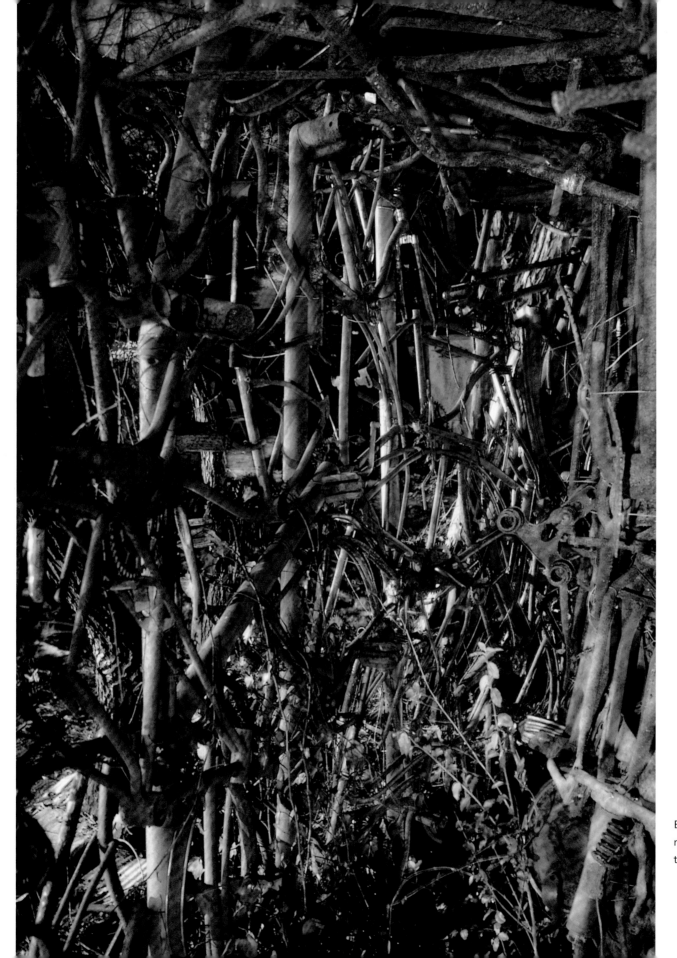

Bicycle sculpture,
mixed media construc-
tion, Paradise Garden

Dilmus Hall

My talent is a gift from God. You are born with it. It doesn't matter who you are, or how beautiful you are, we all are going to die. But your work remains and will be seen for years after you have gone.

Born in Oconee County, Georgia, 1900. Died in Athens, Georgia, 1987.

Having lived in Oconee County until the age of thirteen, Hall moved to Athens, Georgia, where he spent the rest of his life. After returning from service in the armed forces during World War I, he was employed by the Milledge Hotel in Athens, where he worked for twenty-five years. Later Hall took a job working for the Georgia Highway Department on the Danielsville highway and was subsequently employed as a waiter for the University of Georgia sorority houses. He retired in 1961 at the age of sixty-one.

Hall worked predominately with wood, clay, and cement, creating sculptures that were often based on biblical themes. Representations of devils brandishing pitchforks, tableaus of Christ on the cross, and sculptures of human and animal figures littered his yard. Hall occasionally sold his work, but for the last few years of his life it could only be seen in his yard on Dearing Street.

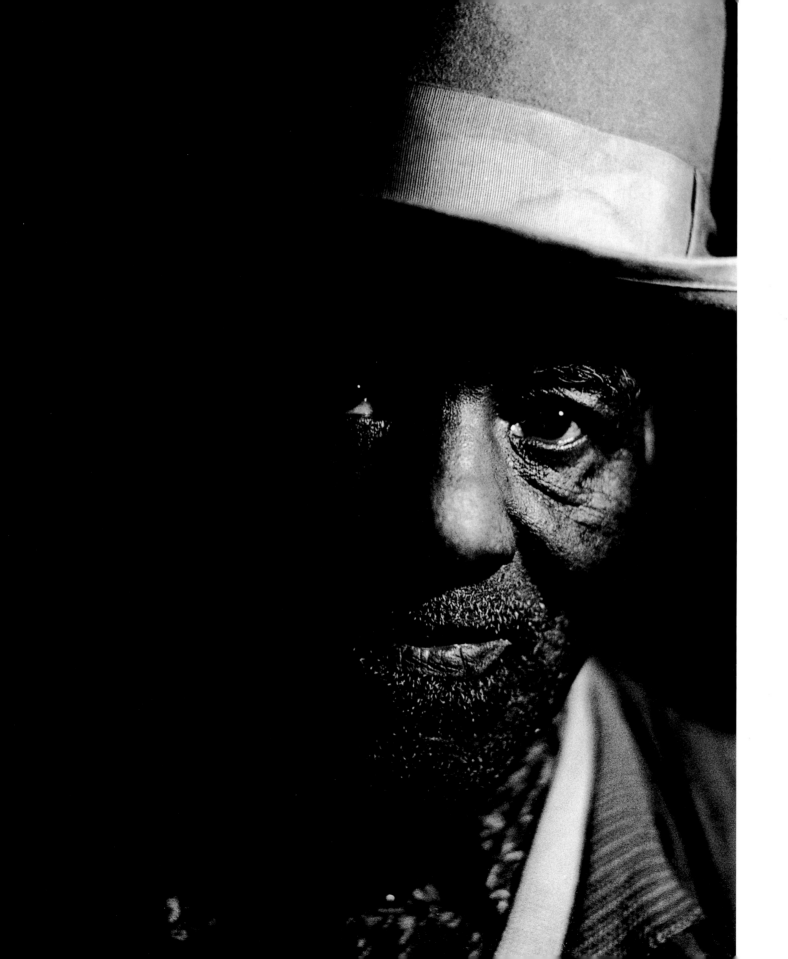

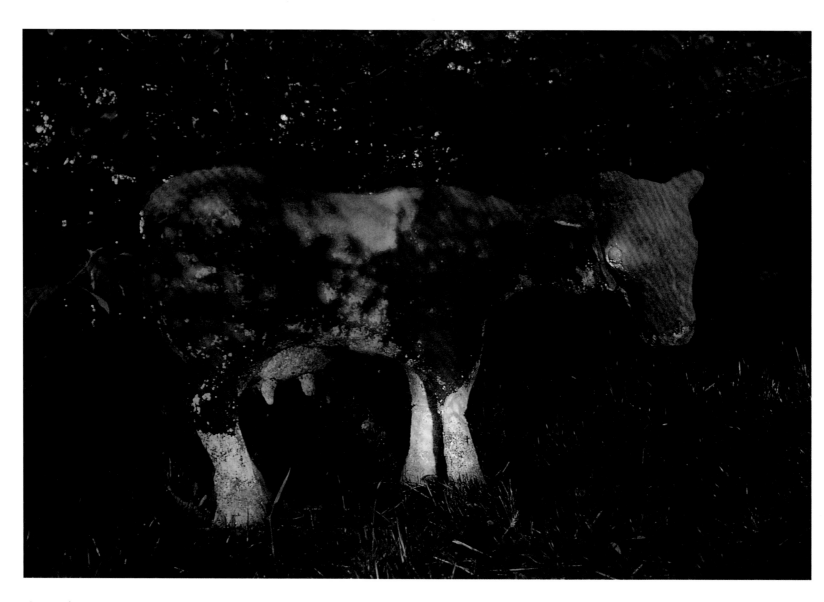

Cow sculpture, cement
and house paint

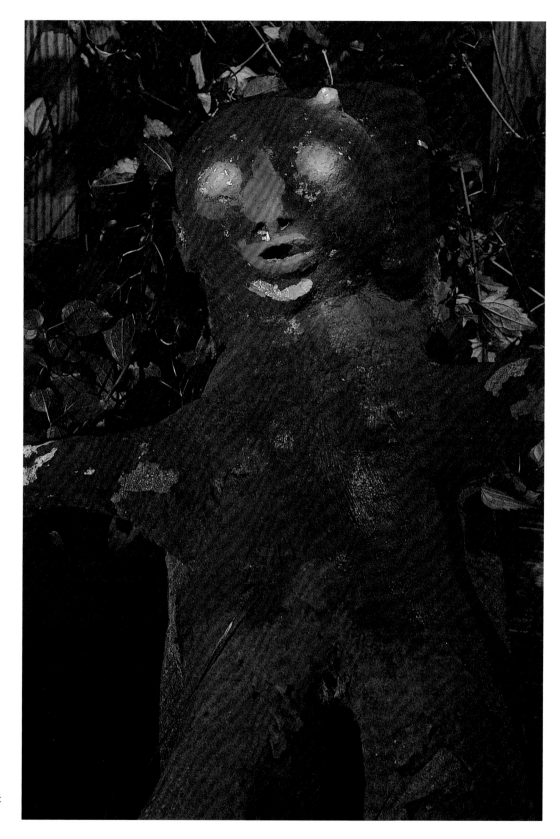

Human figure, cement
and house paint

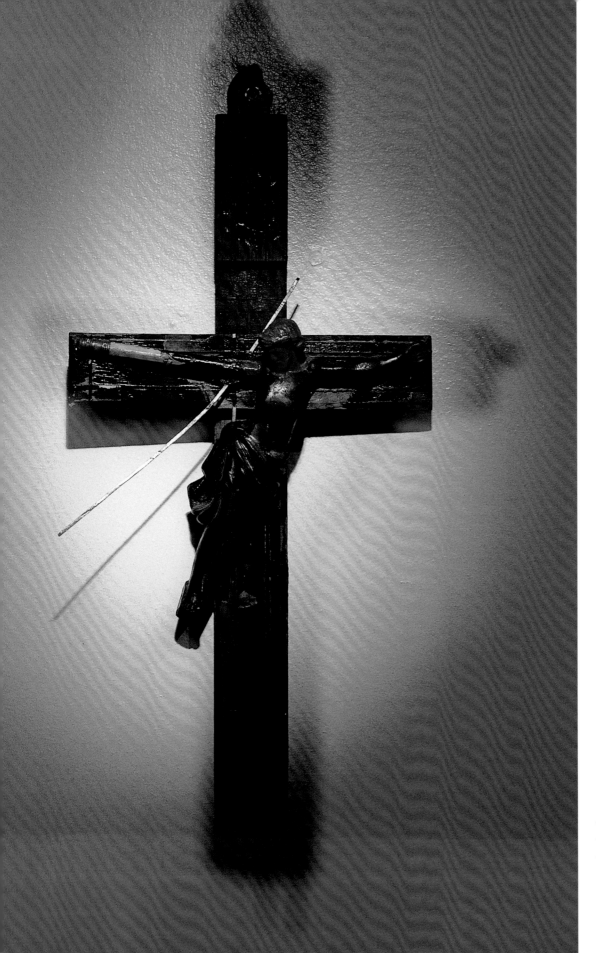

Cross, wood and
found object construc-
tion

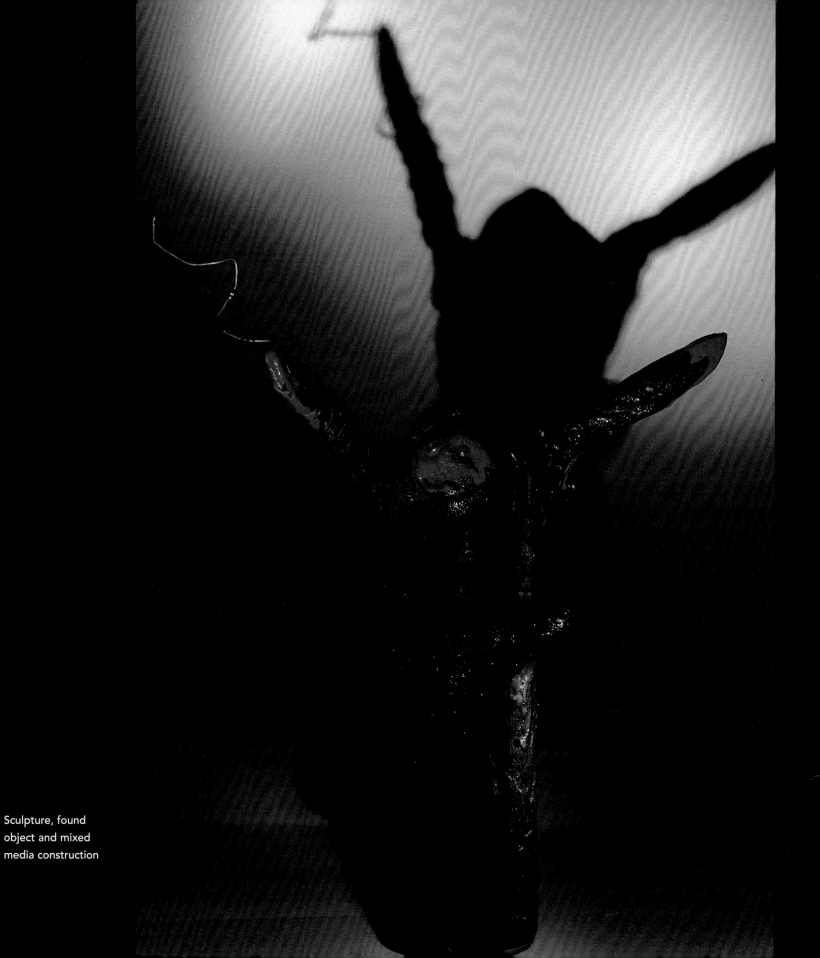

Sculpture, found
object and mixed
media construction

I don't do anything else but this. This is
what I am. I think people need to realize
what we are here for. People sit and
wonder, "There he is up on that hillside.
What the hell is he trying to do?" I am
trying to undo hell. I have an aunt at
home; she's one hundred years old, my
grandfather was eighty-something when
he died, my grandmother was ninety-two.
I am forty-something years old; I'm
halfway to where they are now. We need
to look at things and say, "Hey, do I want
to count myself out at seventeen, or
twenty, or thirty?" I am speaking to the
young minds.

 We are all basically hanging out. We
have to be strong and continue praising
the universe. I am here every day creat-
ing. I want to shout out, scream out,
make sure that people hear what I have
to say. Whether they like my work today
or tomorrow, I don't care. I don't have
the time to worry about that. I only have
the time to create.

Lonnie Holley

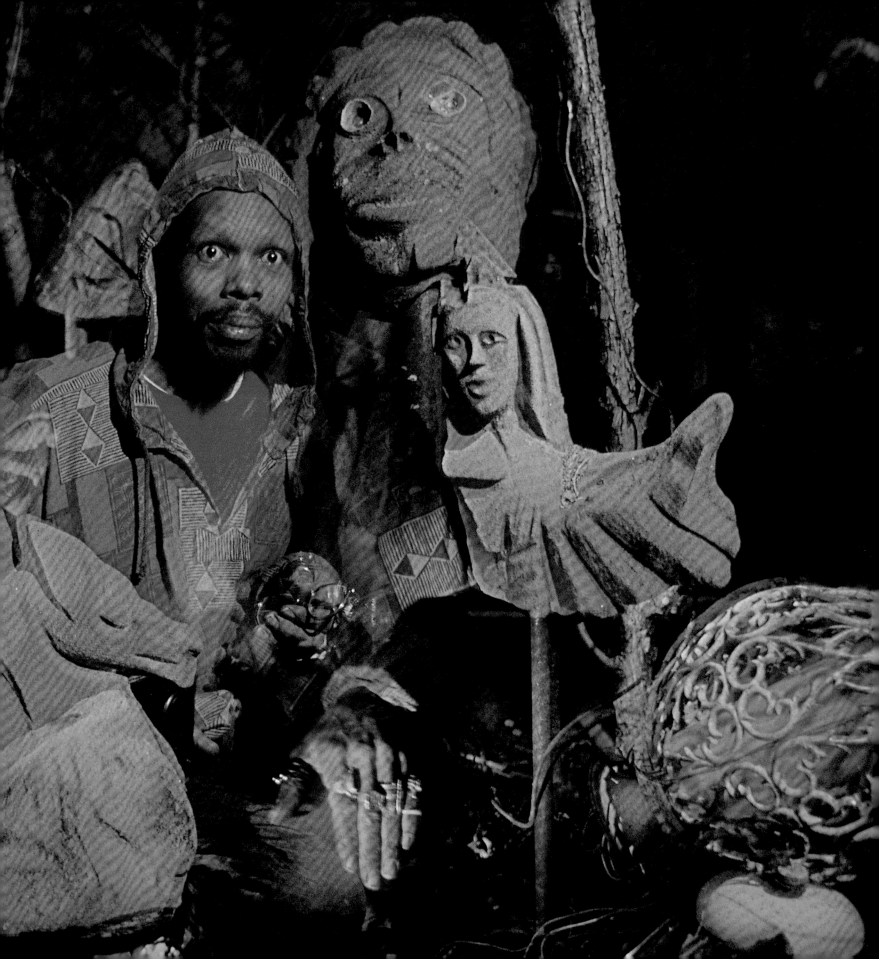

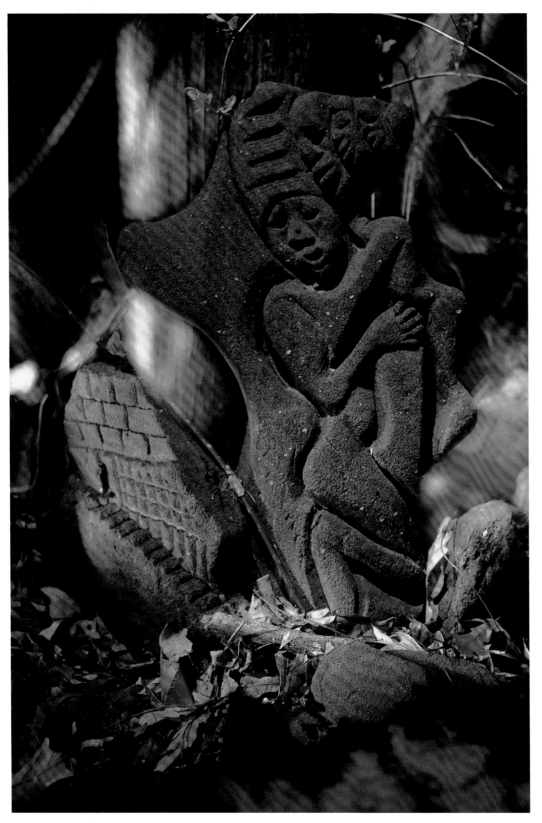

Lonnie Holley

Born in Birmingham, Alabama, 1950.
Resides in Birmingham, Alabama.

Holley's work as an artist began in 1979
when he created two tombstones for his
young nieces who had just died in a house
fire. Since that time, he has produced an
impressive and diverse body of work ranging
from painting and sculpture to found object
assemblages.

As a youth, Holley was taught by his
grandmother to search through trash dumps
for hidden treasures that could be sold at
flea markets. He continues to use and recy-
cle found materials including toys, tree roots,
scrap metal, old clothing, wood, and dis-
carded sandstone from a local steel mill. His
works, which vary greatly in size, content,
and structure, often draw on African art
idioms, such as spirit writing and ancestral
shrines.

Sandstone sculpture,
carved sandstone

Found object sculpture, mixed media construction

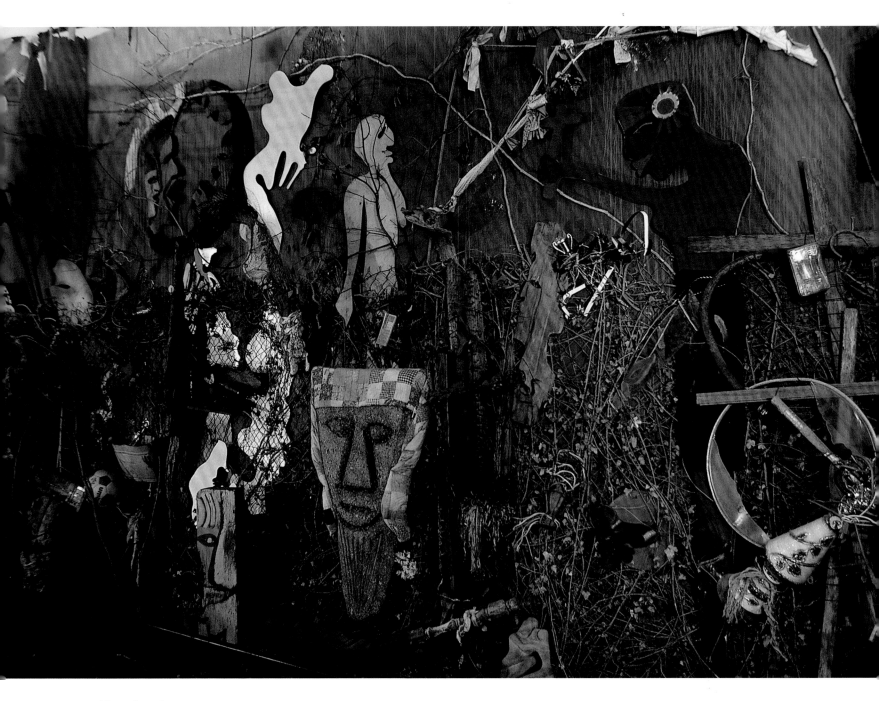

Assemblage, found
object and mixed
media construction

Chair sculpture, found
object and mixed
media construction

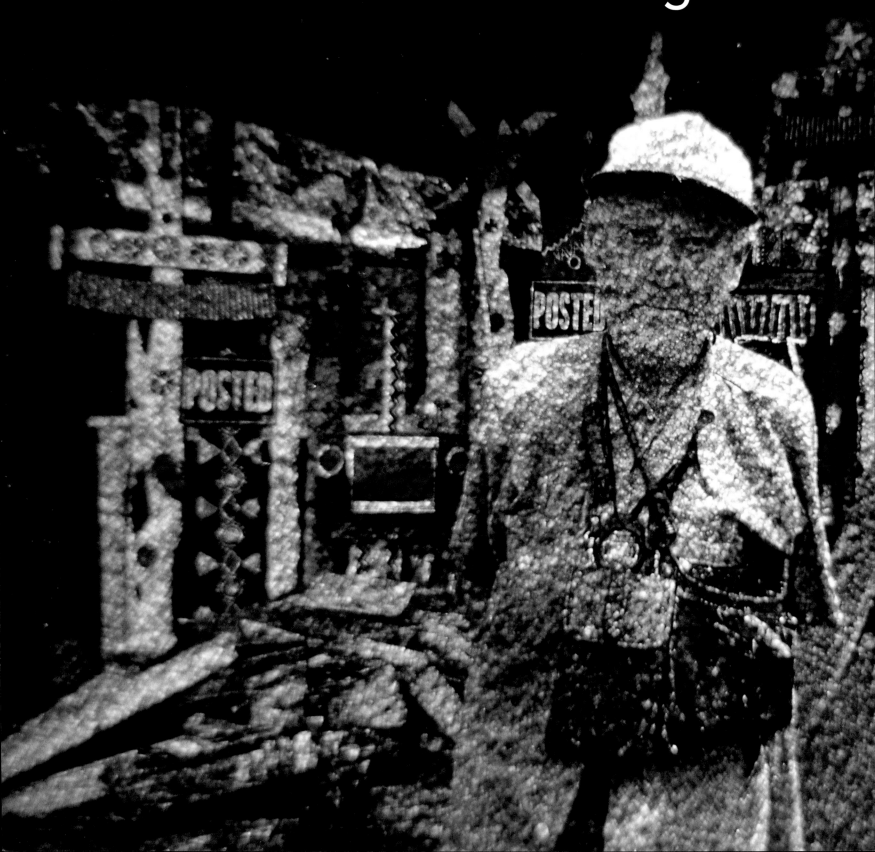

I started out making windmills. I didn't sell them back then. People just knew I was an artist. I don't listen to the radio, or watch TV, or vote. I just go with what comes natural.

Born in Pinnacle, North Carolina, 1931. Resides in King, North Carolina.

Jennings, whose mother was a teacher, was schooled at home after the fifth grade. As an adult, he took odd jobs including work on a tobacco farm and as a film projectionist and night watchman. Jennings began his life as an artist in 1974, when his mother died. Having inherited her farm, he began creating a roadside environment. He built a series of windmills, small houses, and bold colorful signs to display on his property. Jennings calls himself the sun and moon artist, since, according to him, that is where his power comes from.

In 1976 Jennings began selling his art. These works, created with plywood, metal, and house paint, range from ten inches to seven feet and are filled with symbols and themes that reflect Jennings's own philosophy of life. Images of animals, of human figures, and of the sun, moon, and stars are found throughout his work, often combined with painted wooden letters that spell out messages and give title to the pieces.

First shown in *Southern Visionary Folk Artists* in Winston-Salem, North Carolina, Jennings's work has become widely recognized and collected in the United States.

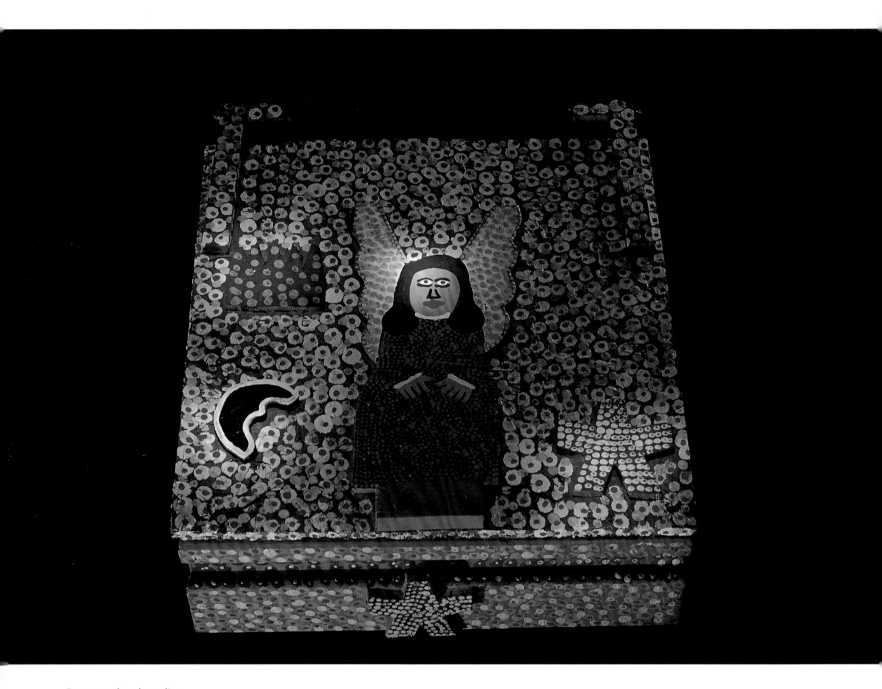

Box, wood and acrylic
paint construction

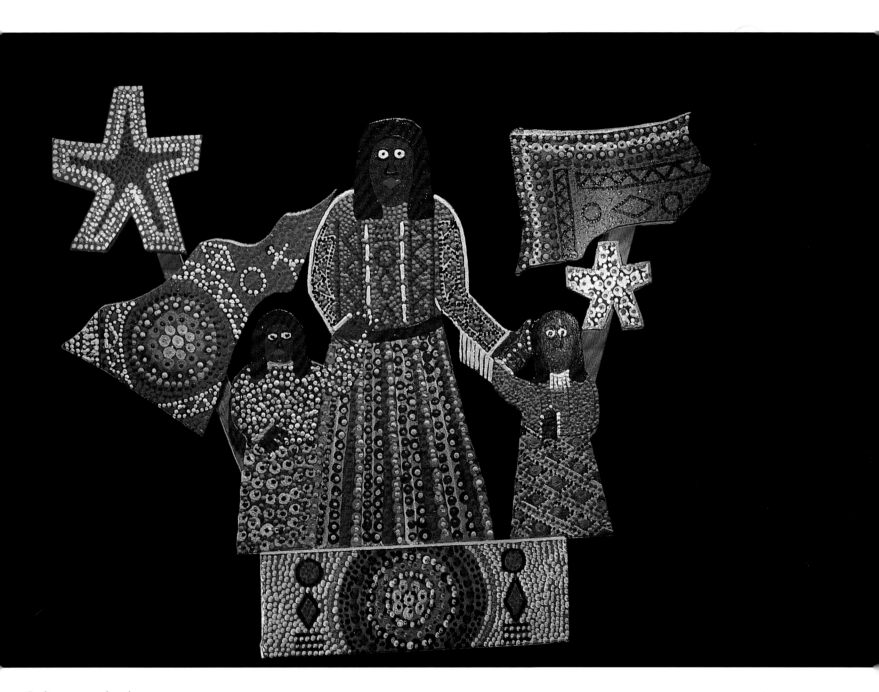

Sculpture, wood and
acrylic paint construc-
tion

You walk through the woods and you see how the wind blows the trees, some of them, dying, making all kinds of animals, stumps, right part of the tree, and dying trees, knots and stuff on it, making turtles and all kinds of stuff. Going through the woods, I see the way the wind turns angles in limbs, the way trees grow. It's pretty nature. It's just like us—it's got life to it. Mother Nature's gonna take it back. We've got a life, and then we gonna go. It reminds me of people a lot.

We see what nature does. You might walk up to a piece of wood, and you don't have to do nothing to it. It's just nature. It's just like taking an animal and freeing it to the world.

I know what I'm going to do when I start. I try to stay as close to Mother Nature as I can. I wake up some mornings with a head full of stuff on it, and a lot of mine is handed down to me from up above . . . and I'm trying to do it. Whatever my mind's got on it, that's what I'm gonna do. Welcome to my world with fish, whales, dolphins, butterflies, snakes, turtles, penguins, and all that.

Clyde Jones

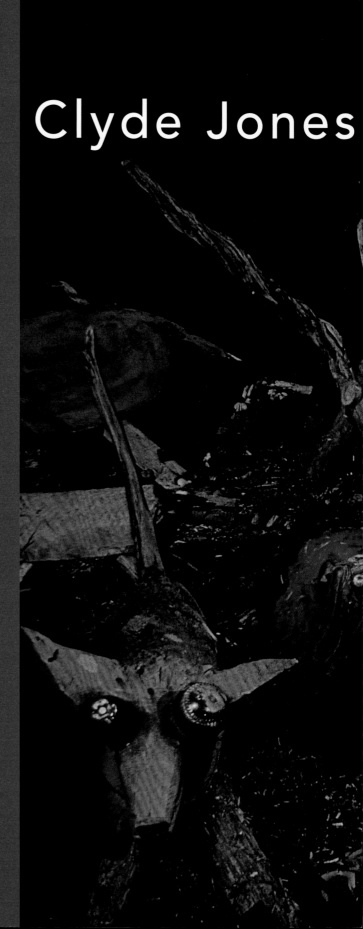

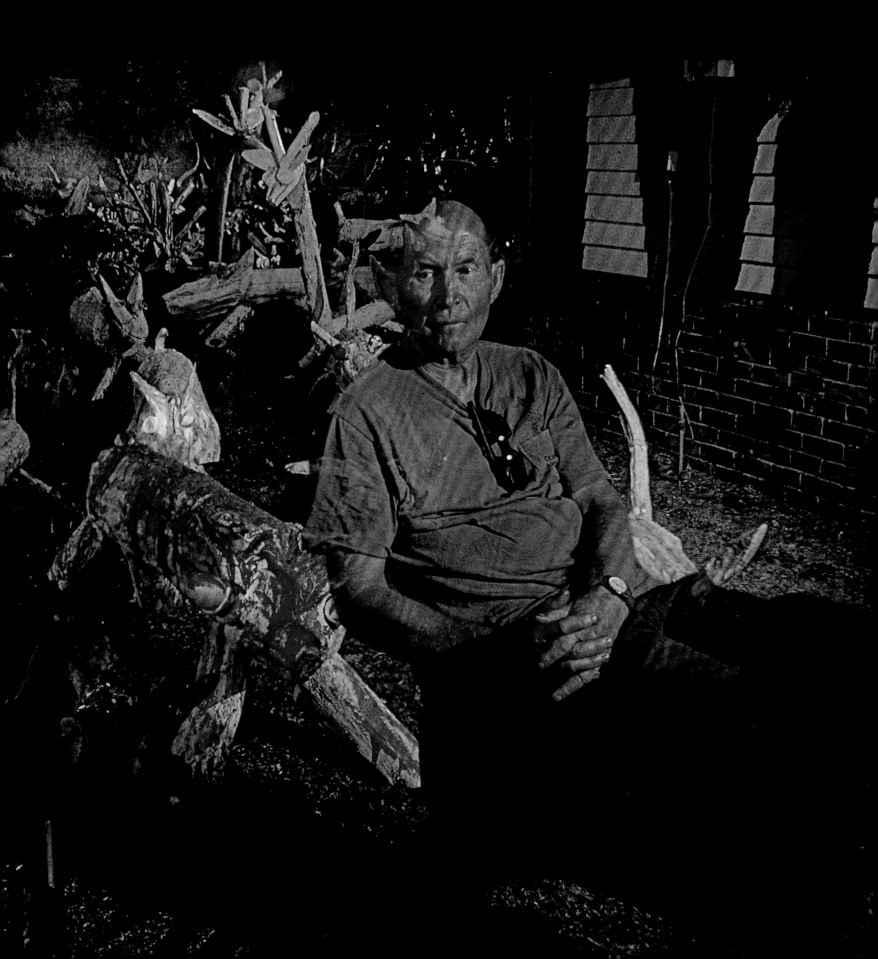

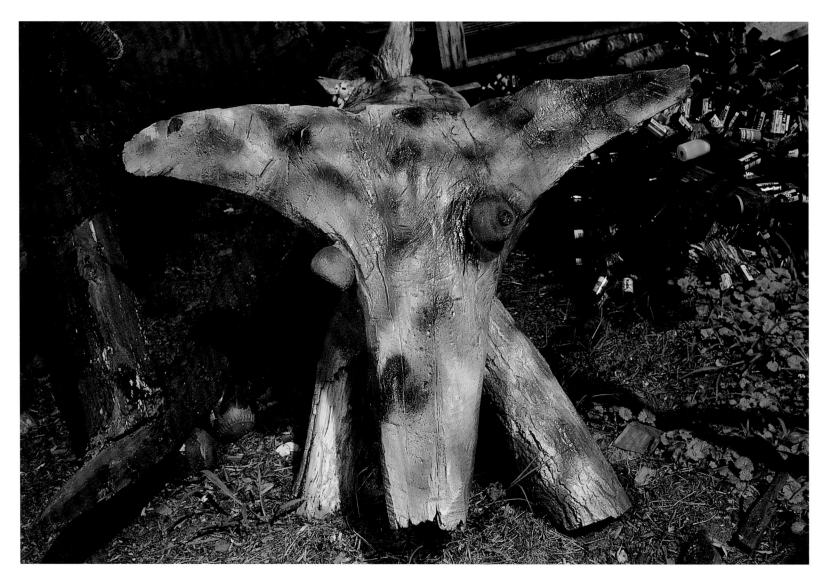

Animal sculpture,
wood and mixed
media construction

Clyde Jones

Born in Rocky River, North Carolina, 1938.
Resides in Bynum, North Carolina.

Jones grew up on a farm in North
Carolina. After attending school intermit-
tently, he did construction work and later
was a pulpwood logger for a textile mill in
Bynum. He was injured in 1979 when a tree
fell on his leg, keeping him out of work for
an extended period. During this time he
began to experiment with artwork, employ-
ing the tools of his former trade.

Using a chain saw, Jones carves fanciful
and sometimes frightening animals, or crit-
ters, as he calls them, and human forms out
of logs and tree stumps. Once cut, the
pieces are nailed together to become fig-
ures. Occasionally painting the sculptures,
Jones also incorporates found objects such
as gourds, bottle tops, tires, and plastic
flowers. More recently, he has begun to
make paintings, which also depict animals
and humans. Despite his popularity over the
past decade, Jones rarely sells his work.

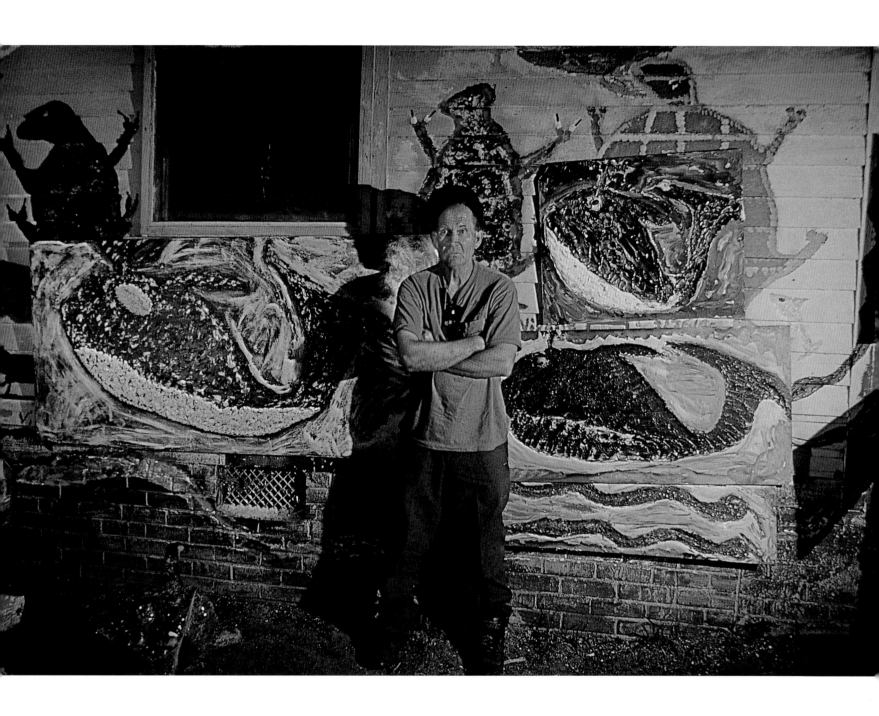

No matter how things diminished for me, or how bad things got, I never gave up on my dream, and my grandmother she never gave up on me either. I will always tell a person to always believe in your dreams, to go for your dreams no matter what. No matter what people think.

There have been plenty of times that I would have liked to have given up, but there was something always deep inside of me that kept me drivin' because I always feel like if I, well, if I would have gave up, I would have always been questioning myself—could I have done it? Some things that I have done with my artwork I am very proud of. A lot of people might have a very different opinion of my artwork, but some pictures I had a strong feeling for, I really put a lot of my heart and soul into. I am very proud of that.

Ronald Lockett

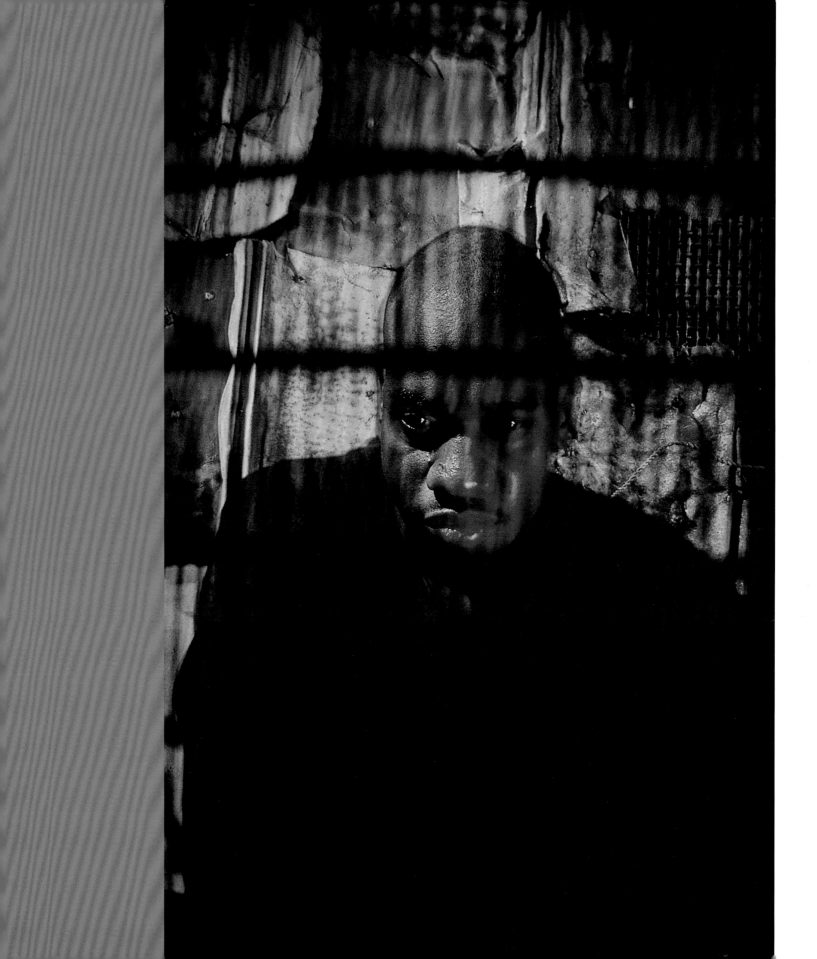

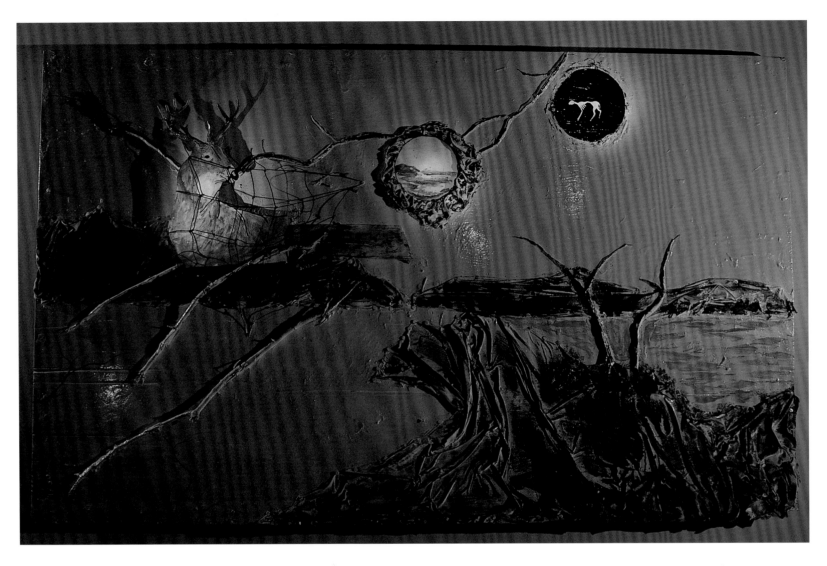

Assemblage, mixed
media on Masonite
board

Ronald Luckett

Born in Bessemer, Alabama, 1965.
Resides in Bessemer, Alabama.

Lockett has been interested in drawing
and painting all his life; art class was his
favorite course throughout school. With the
encouragement of his extended family and
the success of his cousin Thornton Dial, Sr.,
Lockett began taking his work seriously in
the late 1980s.

Although he paints primarily on plywood
using oil-based house paint, Lockett also
uses artists paints, applying them to
Masonite or canvas and occasionally incor-
porating an assortment of found materials
such as sticks of wood and pieces of fencing
or other metal. Many of his works offer
social commentary, dealing with personal
and political themes such as homelessness,
the environment, famine, and disease. He
has become recognized in recent years, and
his art can be found in various public and
private collections throughout the United
States.

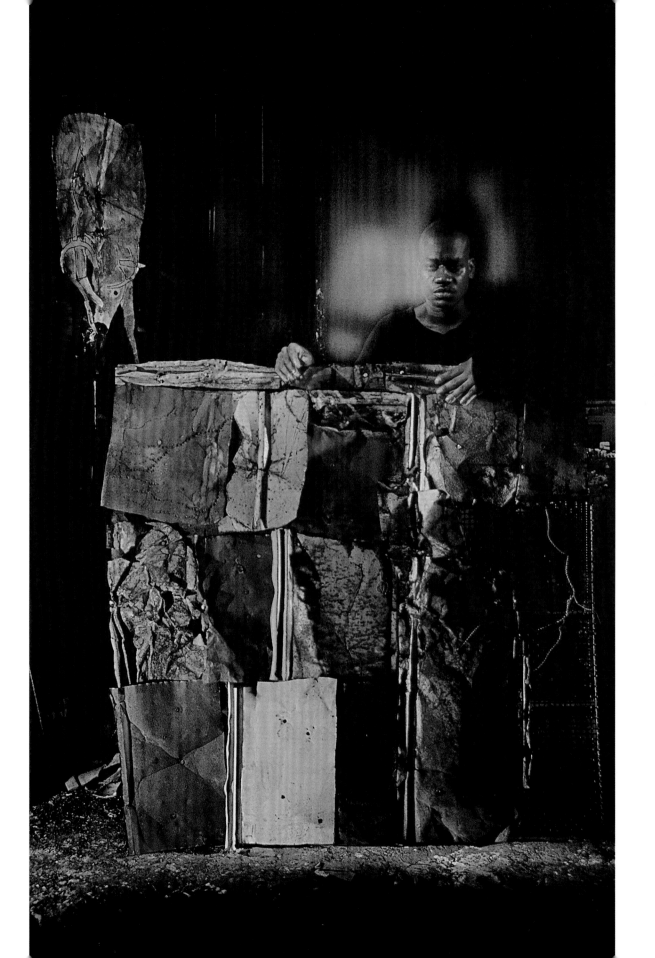

Assemblage, mixed
media on metal

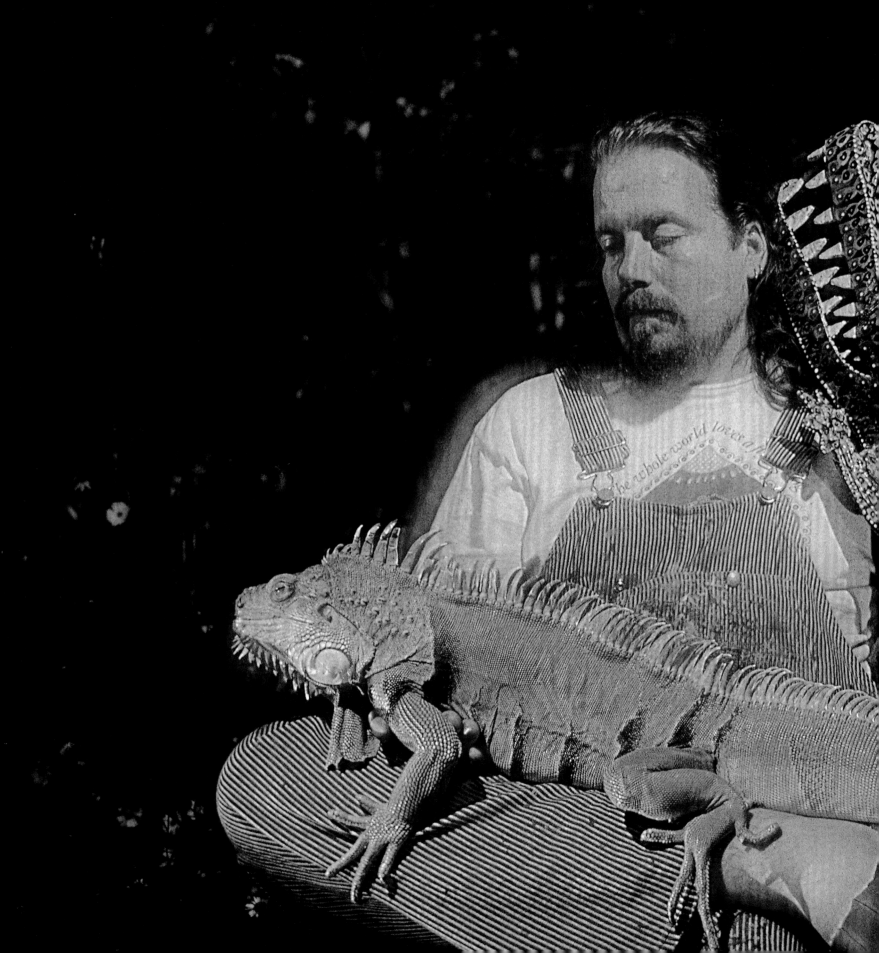

Peter Loose

I am truly, truly living my dreams right out on the table. When you see something that I created, it is like I pulled my brain right out and threw it on the sidewalk, and most people don't get to do that. You could tell somebody about your ideas, you could drama them through the earth and show them something with your words. But until you physically hand them something, I think that it is almost impossible to show them what is in your brain, what is in your true spirit. I think if you ever pick up any of my stuff, you do get the opportunity to go, man, this dude has got something going on.

I really feel like I am able to show them something right in their hands, and they don't have to ask questions at that point. Either you get it or you don't. There it is, this is me. I put it out freely for you to figure on.

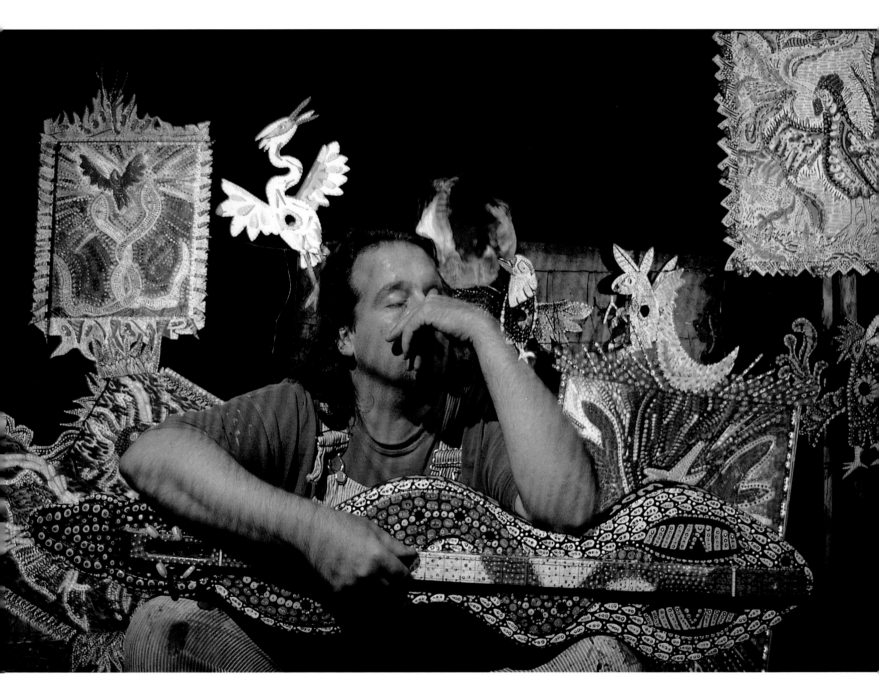

Peter Loose

Born in Silver Spring, Maryland, 1963. Resides in Hull, Georgia.

Loose has always been fascinated with nature and worked as a naturalist for a Maryland state park and later for the Audubon Society. In 1986 he moved to Athens, Georgia, to work for the Sandy Creek Nature Center and began painting. Loose creates whimsical paintings, birdhouses, and sculptural musical instruments, his trademark being snake-shaped dulcimers.

Loose and his wife Sandy (who, he says, is the only one who knows when a given work is finished) share their six acres with a wide variety of once-abandoned animals including three dogs, and Loose's studio mates—a boa, a python, and an iguana.

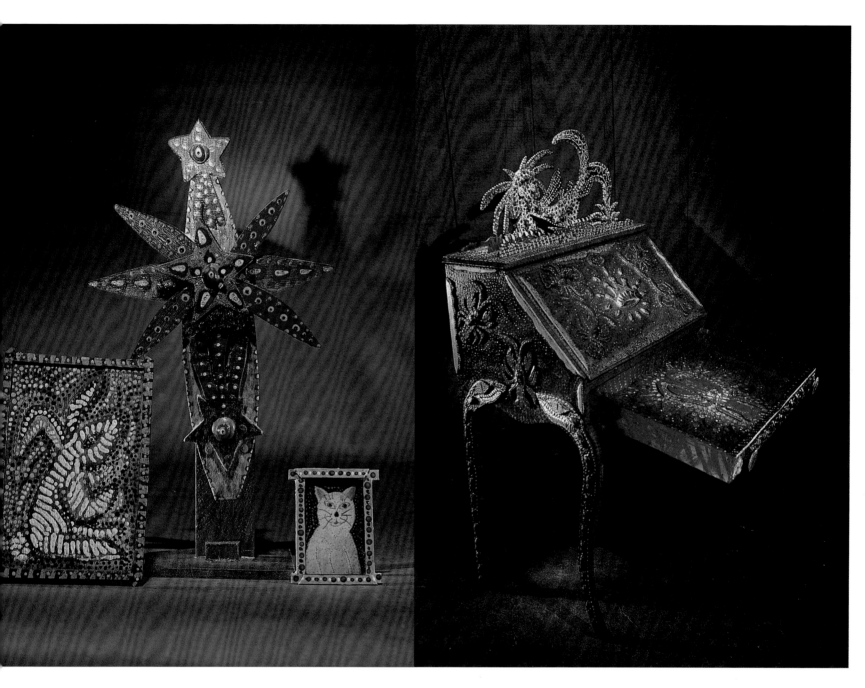

Sculpture, wood and
acrylic paint construc-
tion

Painted furniture,
wood and acrylic paint

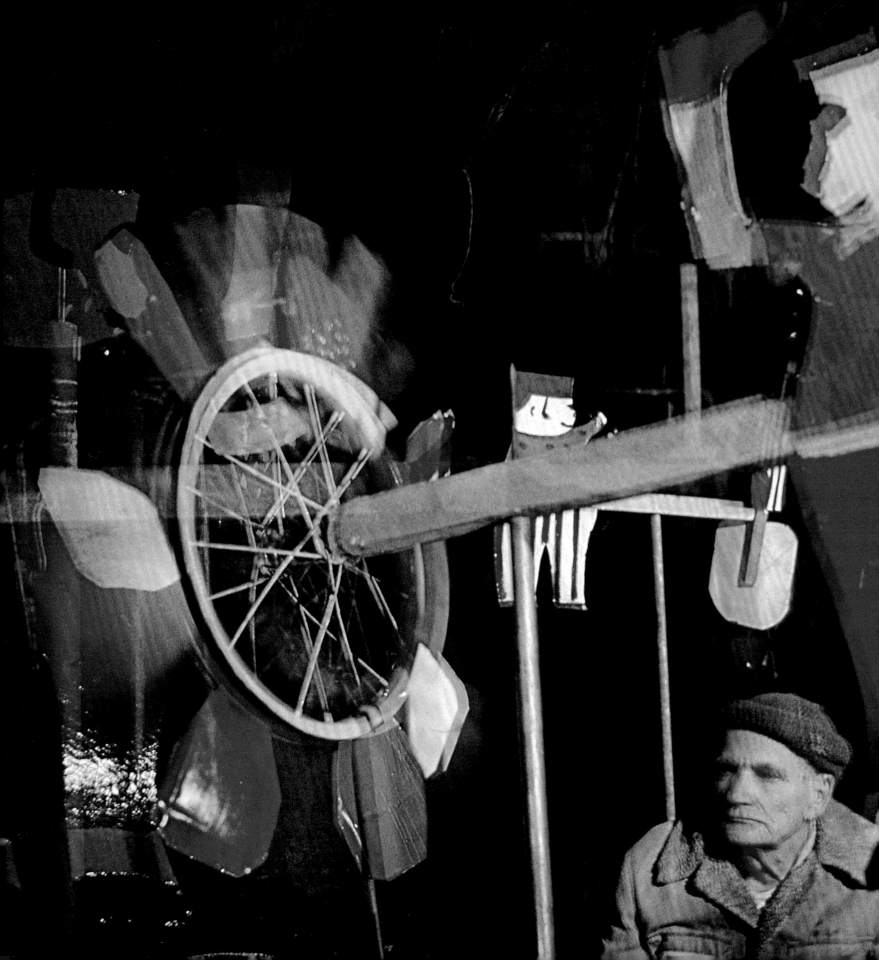

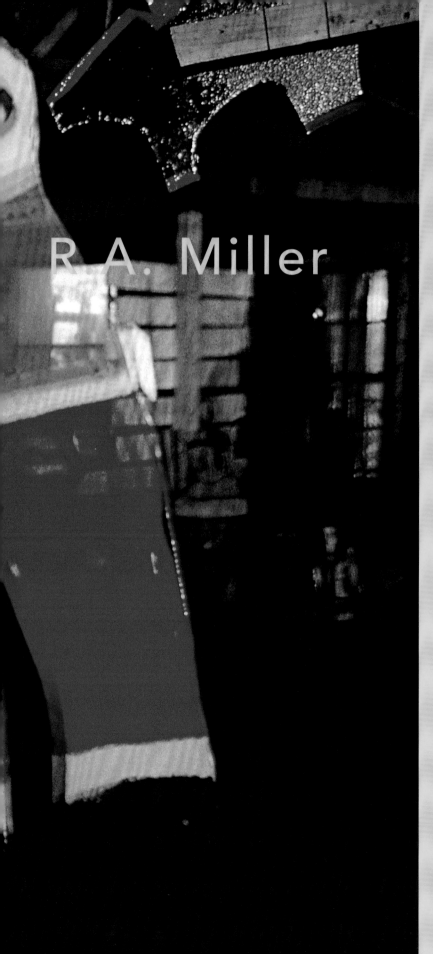

R.A. Miller

I don't understand why people buy this junk. It doesn't make any sense to me. I would make these things anyway.

Born in Gainesville, Georgia, 1912. Resides in Gainesville, Georgia.

Miller, who labored as a farmer and cotton mill worker for most of his life, is also an ordained minister. After retiring for health reasons, he began creating art to spread his spiritual message. He is best known for whirligigs and cutouts made of tin. Miller also uses enamel paint and felt-tip pens to create works on drawing boards and on paper and Masonite boards. He uses a hammer to flatten discarded gutters, cuts out silhouettes of animals and figures, embellishes the shapes with images and words, and then attaches them to his whirligigs or displays them as freestanding works.

A visitor can literally go whirligig picking in Miller's back yard, which is covered with the pieces displayed atop metal poles. This backyard environment first brought him regional recognition in the early 1980s. His work is now collected throughout the United States.

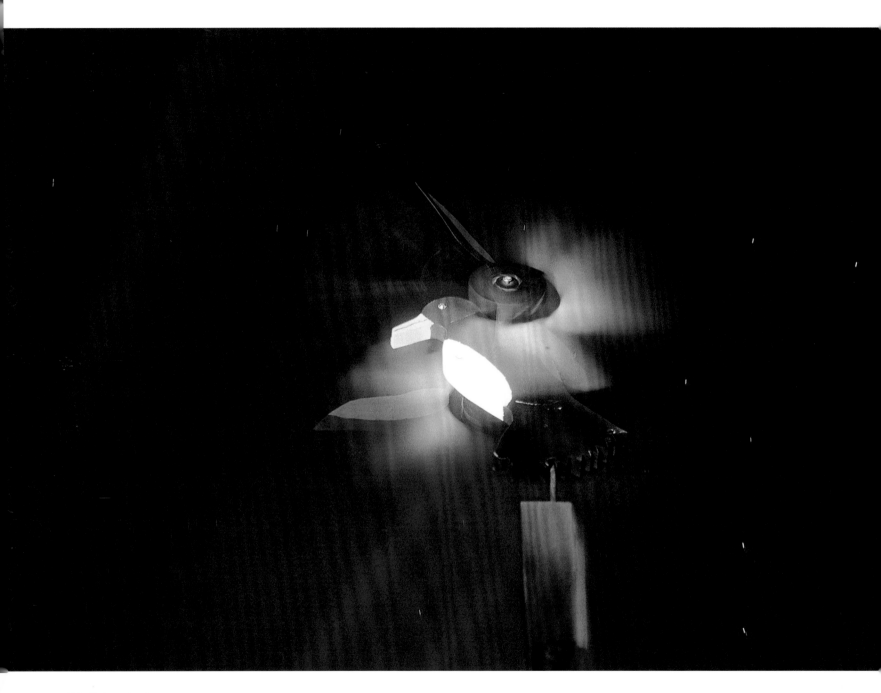

Whirligig, mixed
media construction

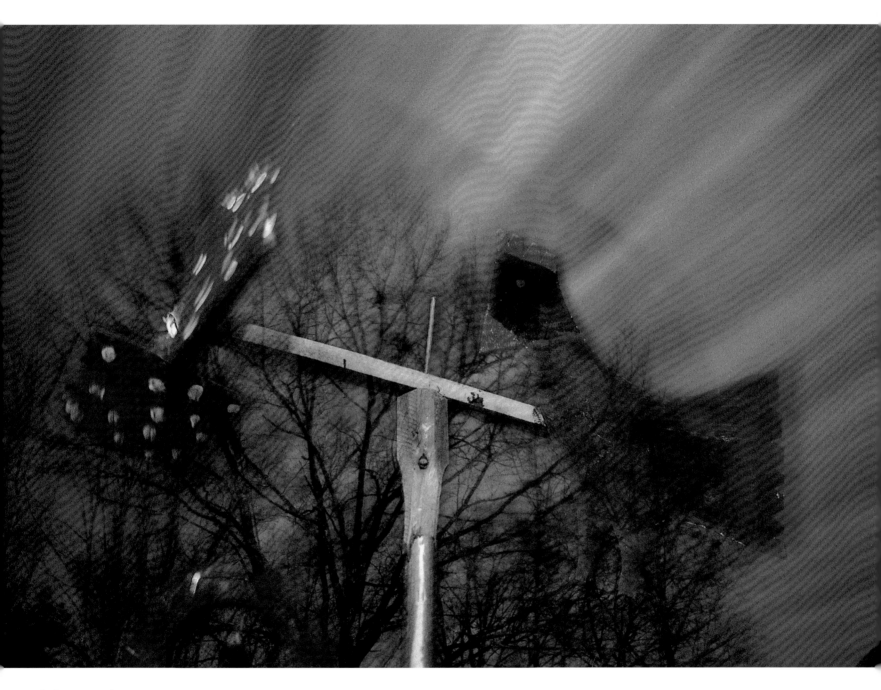

Whirligig, mixed
media construction

A.J. Mohammed

The most important thing to me about my artwork is that it is a relief to me. It gives me some kind of consolation. When I first started making art, I wouldn't sell it, because I fell in love with it. I would put it up on the walls everywhere. I painted a lot before I lost my eyesight. Now I just carve.

I try to put messages in my work; this is how I can get over to people. Messages about how to live better, how to live right. To help people get through things, to help them get through their problems.

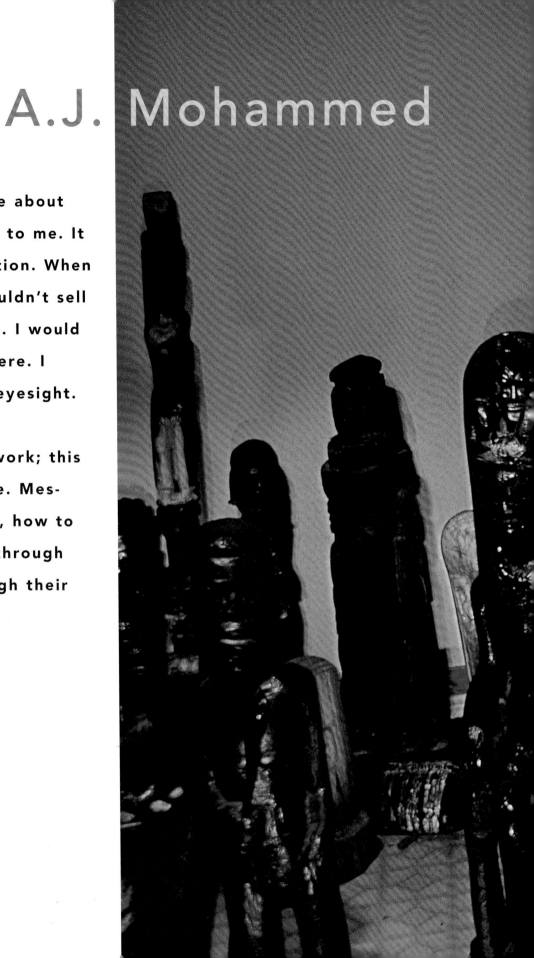

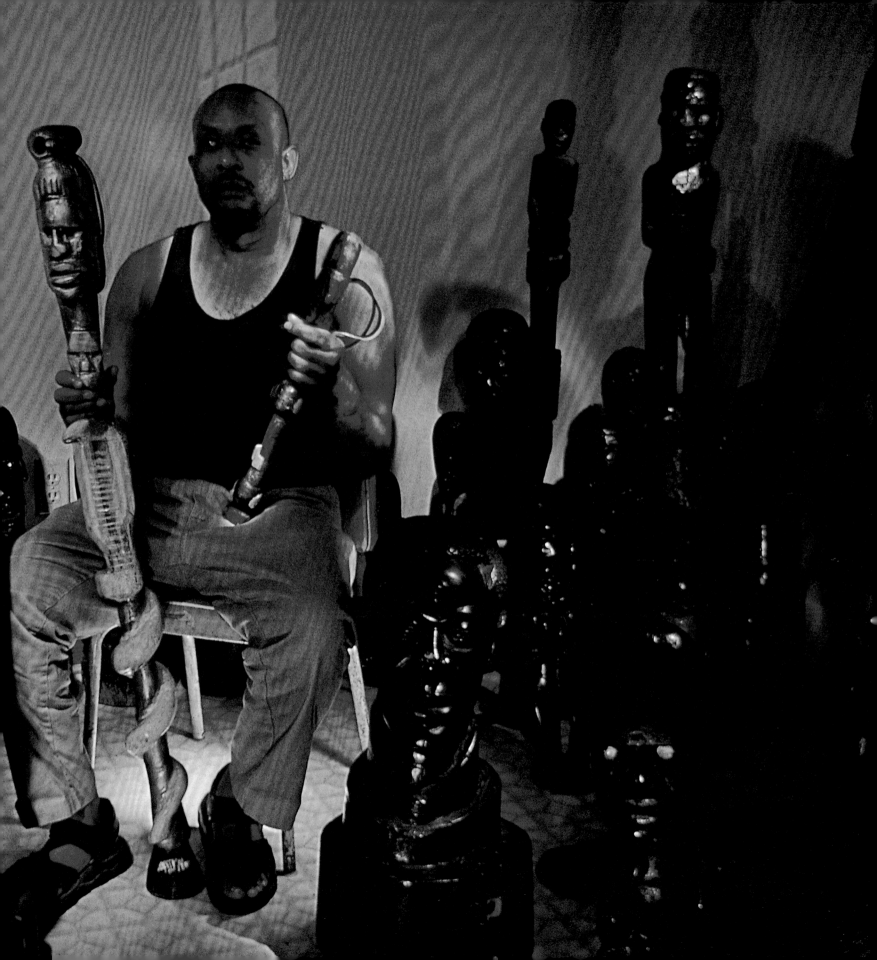

A. J. Mohammed

Born in Yazoo City, Mississippi, 1937.
Resides in Yazoo City, Mississippi.

Growing up in Yazoo City, Mohammed
started making art at the age of five, when
he and his brother created drawings and
comic books for themselves and friends. He
began selling his work in 1969. At the time
he was also employed as a construction
worker and lived in various places, including
Annapolis, Maryland, and Memphis, Tennes-
see. After he returned to Yazoo City in 1977,
he was blinded by a shotgun blast to the
face.

Early in his career, Mohammed worked
primarily as a painter. After losing his eye-
sight, he concentrated on sculptural work.
Using a single piece of wood, he carves
human figures, snakes, and various other ani-
mals. He also carves walking sticks an staffs.
His work is now represented by a number
of galleries and can be found in the perma-
nent holdings of several museums in the
southern United States.

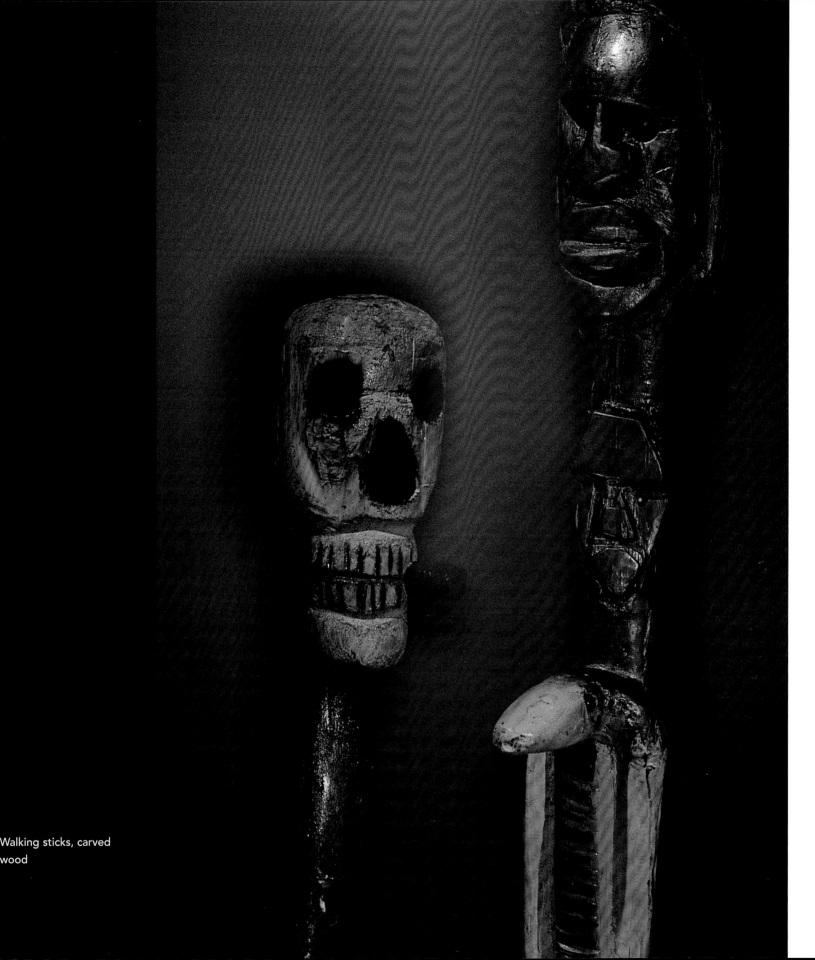

Walking sticks, carved
wood

I got saved on April 24, 1960. It was then that the Lord instructed me to put up these crosses in the yard. Some people call me an artist; some people call me a weirdo. I don't care what they call me, you know what I mean? I never really have been involved in art, but people come from all over to see me. They hear about me from other people or read about me somewhere. I work sometimes ten hours a day. I do this because it is what I am supposed to be doing, not because I am an artist, not for myself. I work for the Lord and for others.

W.C. Rice

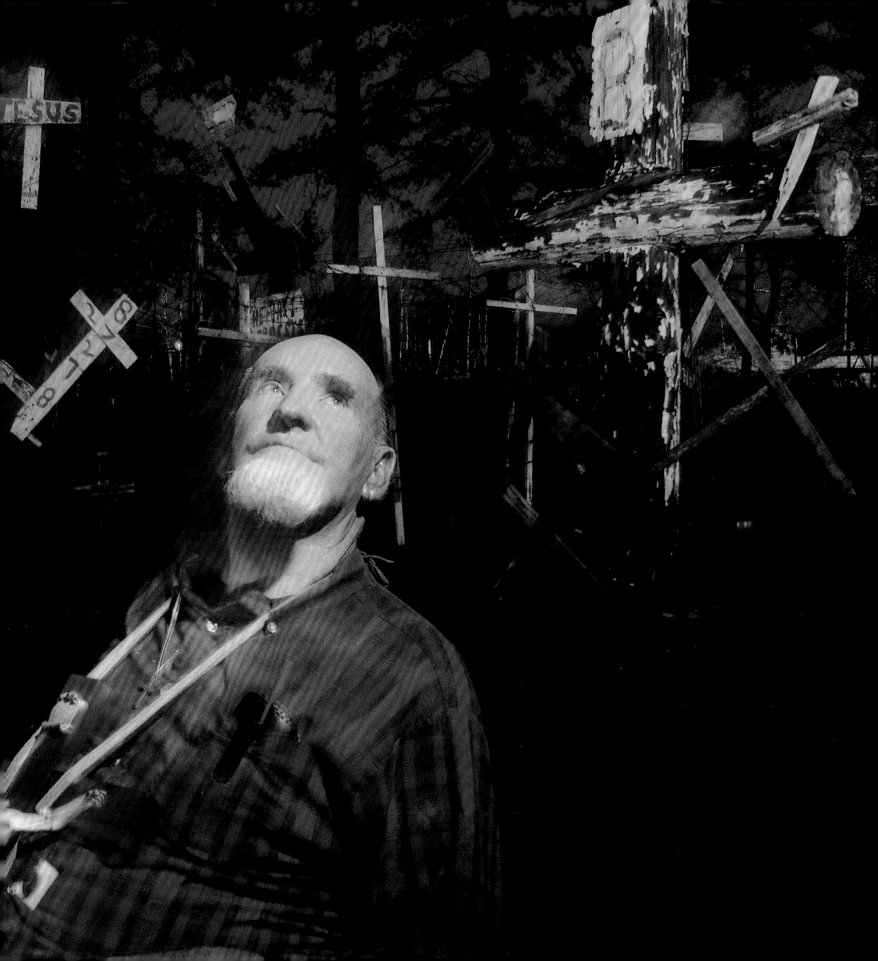

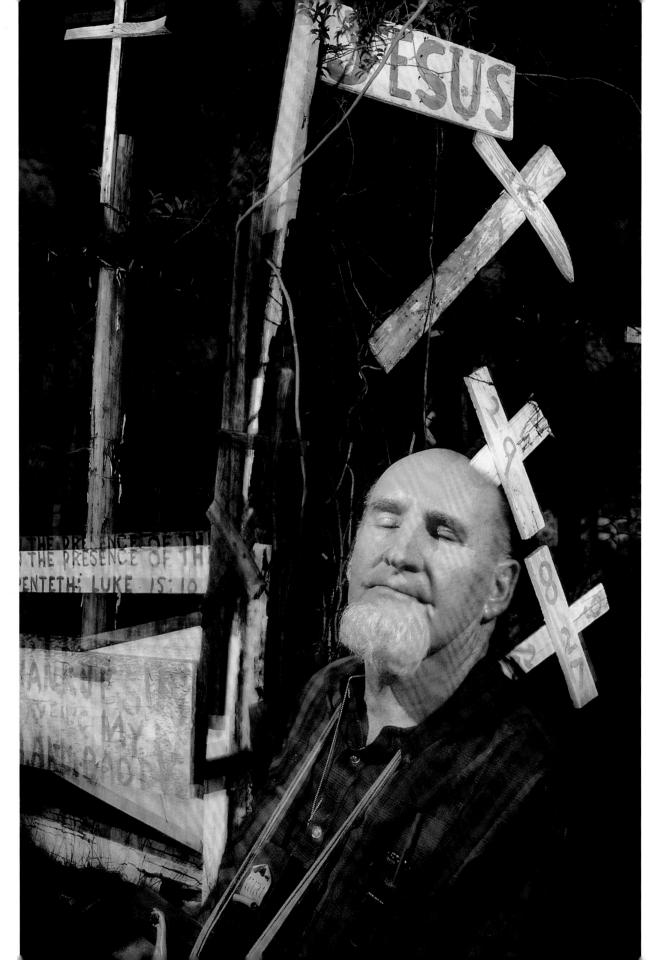

Yard crosses, wood
and nails >

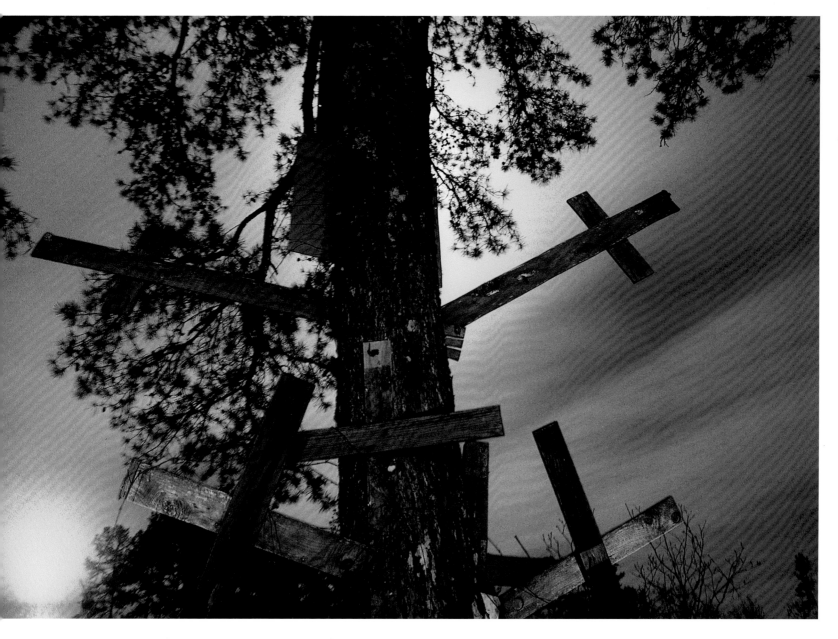

W. C. Rice

Born in Bibb County, Alabama, 1930. Resides in Prattville, Alabama.

Rice, a house painter by trade, spent his early years working in and around Bibb County, Alabama. On April 24, 1960, he was "saved" and became a devout Christian. Soon after, Rice began constructing crude crosses and placing them around his property in Prattville. Starting with twenty-four (representing the day of his redemption), he has now made hundreds, and they fill every room in his house. Occasionally painted, some of the crosses stand twenty feet or higher. Crosses have been erected on both sides of his roadway property. Rice has also constructed small shrines and made signs depicting biblical stories and bearing messages of redemption.

Rice does not consider himself an artist, but he welcomes visitors who come from all over the country to see his roadside extravaganza.

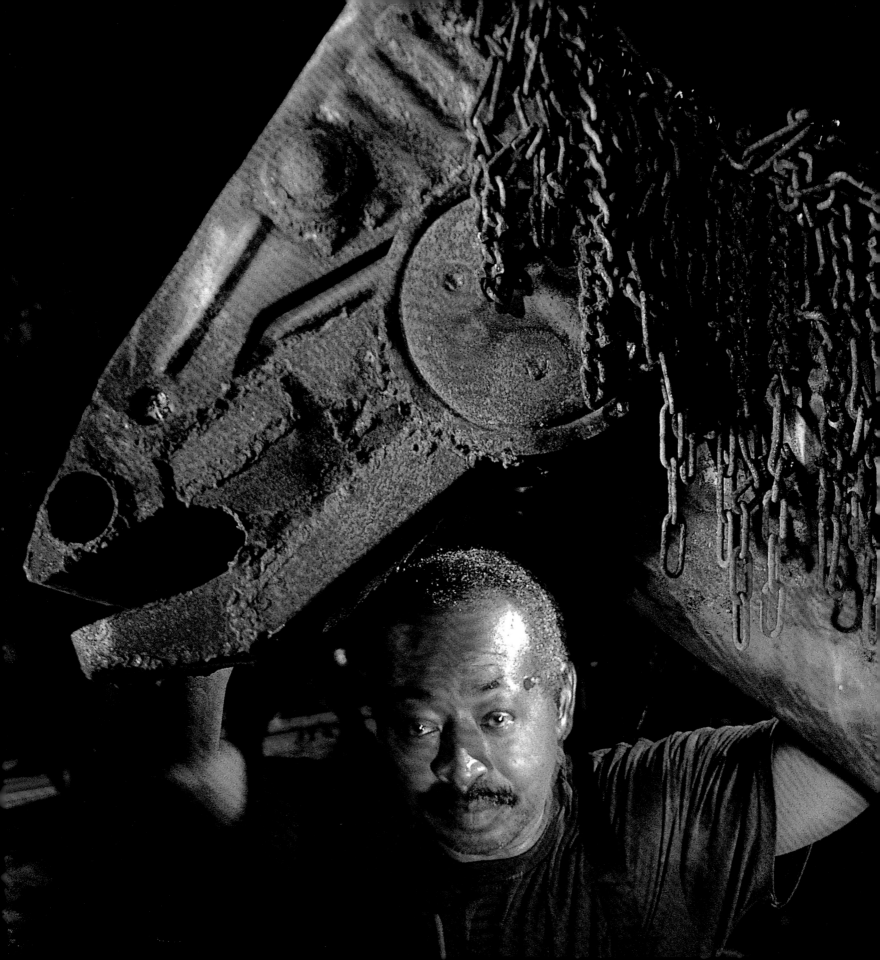

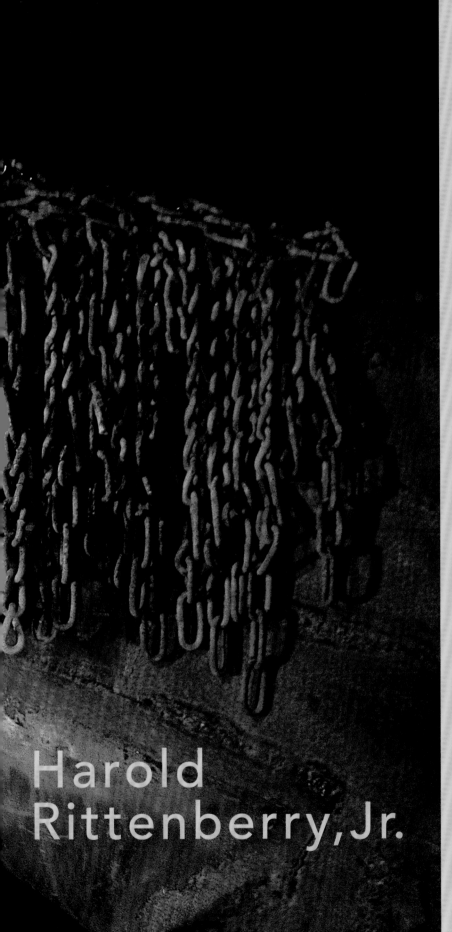

Harold
Rittenberry, Jr.

Art is like a food to me. It is something I just have to do. It is like eating, drinking water, and breathing air. I just can't put it off.

Art is something like a gift, I guess. Everything I see, I see it in there. When I was younger, I worked in a fabrication plant, and I fell in love with welding. Since then it is what I always wanted to do. I like to make the sculptures come alive. To me they come alive and talk to each other. I want them to communicate with you. I will be walking down the street and I see a piece of metal, and it just starts talking to me. I throw it in a pile and wait until the moment comes and it starts talking to me. It tells me its story. It tells me about where it was, what it did. It might have once been an old shovel or car part. It tells me about its life, about the people who used it. They all tell different stories. You can see part of yourself in them. They reflect everything.

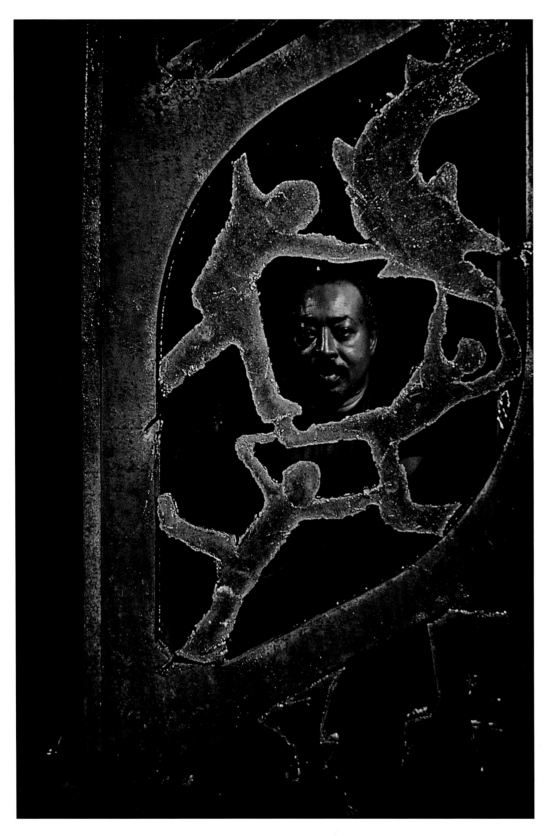

Harold Rittenberry, Jr.

Born in Athens, Georgia, 1938.
Resides in Athens, Georgia.

Having grown up and attended school in Athens, Rittenberry enlisted in the army. He later took a job at a steel fabrication plant in north Georgia, which is where he learned how to weld and work with metal.

Inspired by dreams, television, magazines, and books, Rittenberry uses found as well as bought objects in his sculptures and views his work as the ultimate form of recycling. Discarded parts from vacuum cleaners, automobiles, and air conditioners, old metal chair frames, new and used garden tools, and door handles are combined in his creations of robots, helicopters, fish, birds, humans, and other whimsical forms. These are prominently displayed in his front yard. Rittenberry's work is represented by several galleries and private dealers and can also be found in numerous public and private collections throughout the United States.

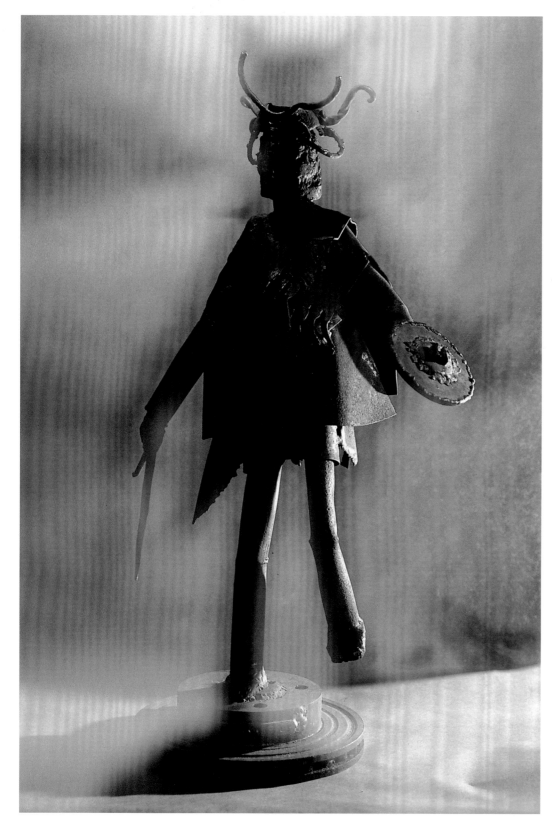

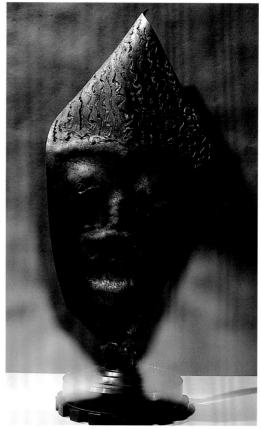

Metal sculpture,
welded metal, found
object assemblage

Metal sculpture,
welded metal, found
object assemblage

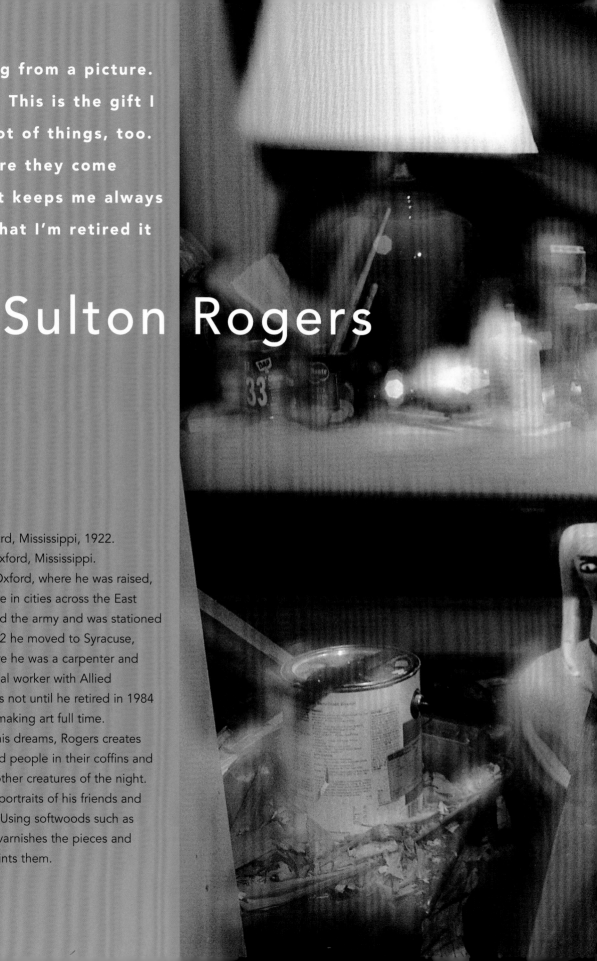

I can make most anything from a picture. If I see it, I can make it. This is the gift I have. And I make up a lot of things, too. I'm not always sure where they come from. I like it, though. It keeps me always doing something. Now that I'm retired it keeps me busy.

Sulton Rogers

Born in Oxford, Mississippi, 1922. Resides in Oxford, Mississippi.

Rogers left Oxford, where he was raised, to travel and live in cities across the East Coast. He joined the army and was stationed in Texas. In 1952 he moved to Syracuse, New York, where he was a carpenter and then an industrial worker with Allied Chemical. It was not until he retired in 1984 that he began making art full time.

Inspired by his dreams, Rogers creates carvings of dead people in their coffins and of snakes and other creatures of the night. He also makes portraits of his friends and acquaintances. Using softwoods such as sugar pine, he varnishes the pieces and occasionally paints them.

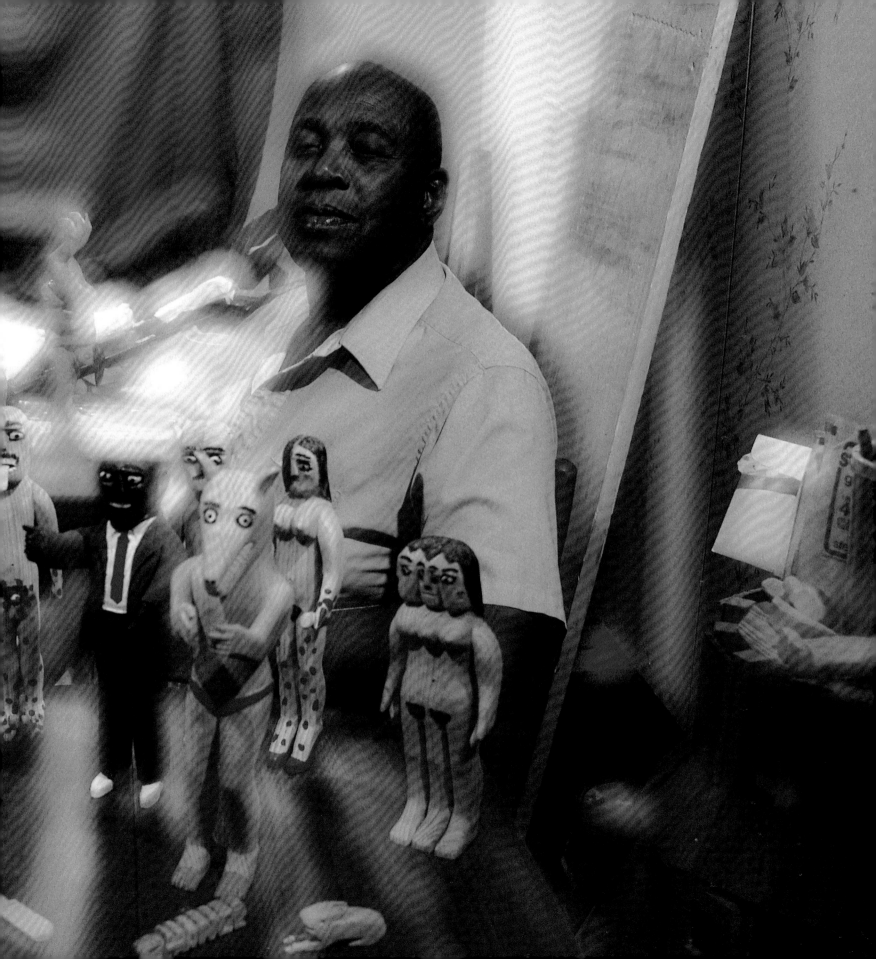

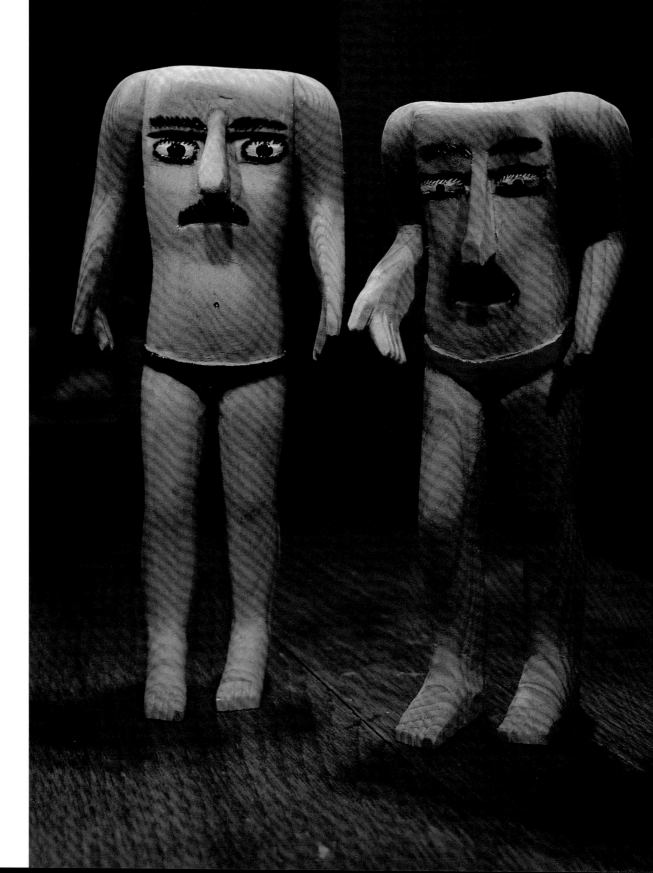

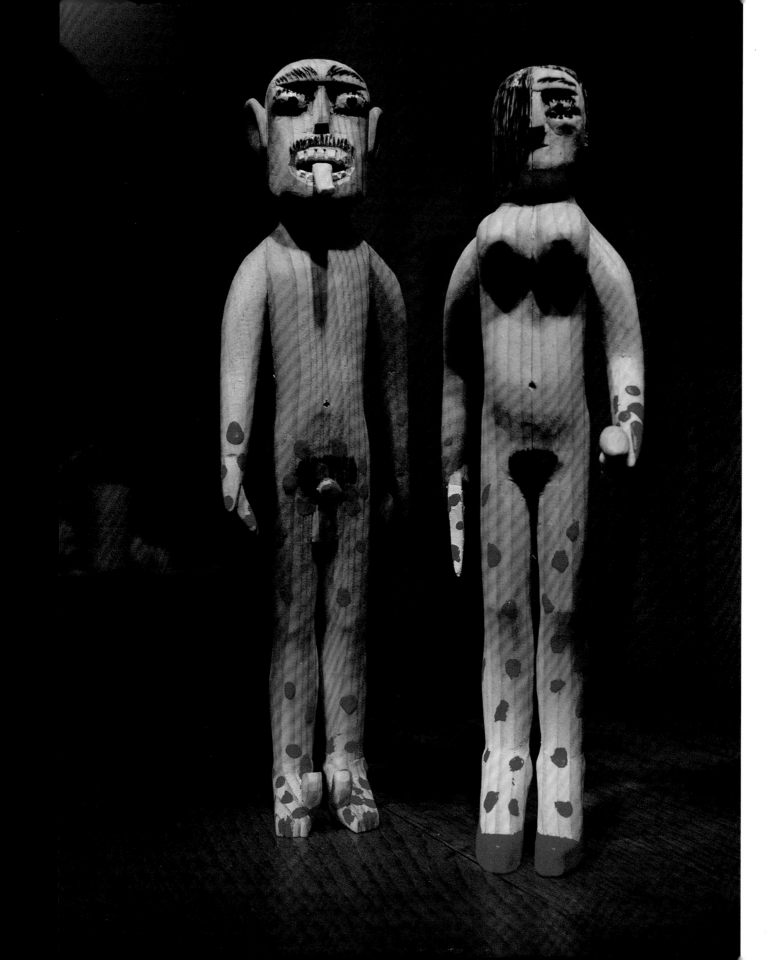

Reverend John D. Ruth

I'm a poet, a musician, a sculptor, and all. I've got ten talents. I taught school for thirty years. I have a degree from college. I am a mystery to my whole town. They don't understand why I do these things. The Lord gave me these talents.

Jesus came in my room one night. I got scared. I bent down and raised my arm, and he kissed my hand. He said, "John D. Ruth will work!" I was at the university for ten years. I was in a band. But that was the devil's work. He didn't want me playing all of that. I had to come to God. The trees tell you there's a God. Elephants tell you there is a God. But where God came from nobody knows. He's been here all the time. The devil came to me to like Jesus did, but the devil don't like light. I turn on the lights for everyone.

ASSYRIA

EGYPT

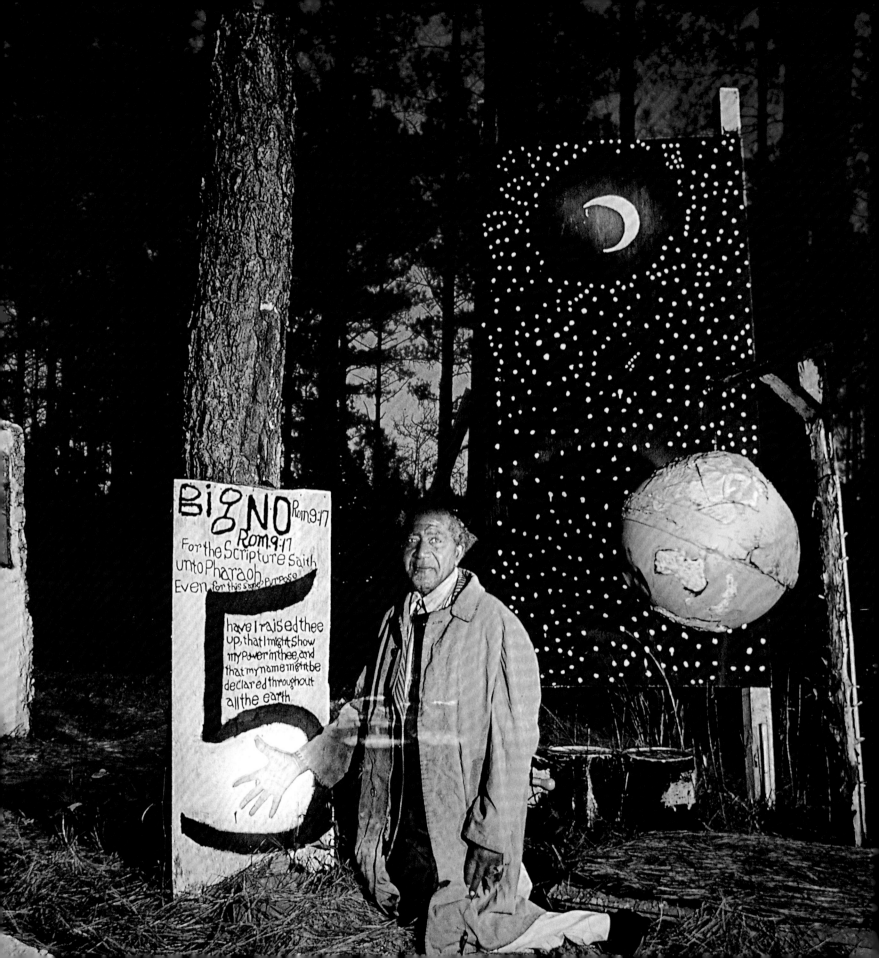

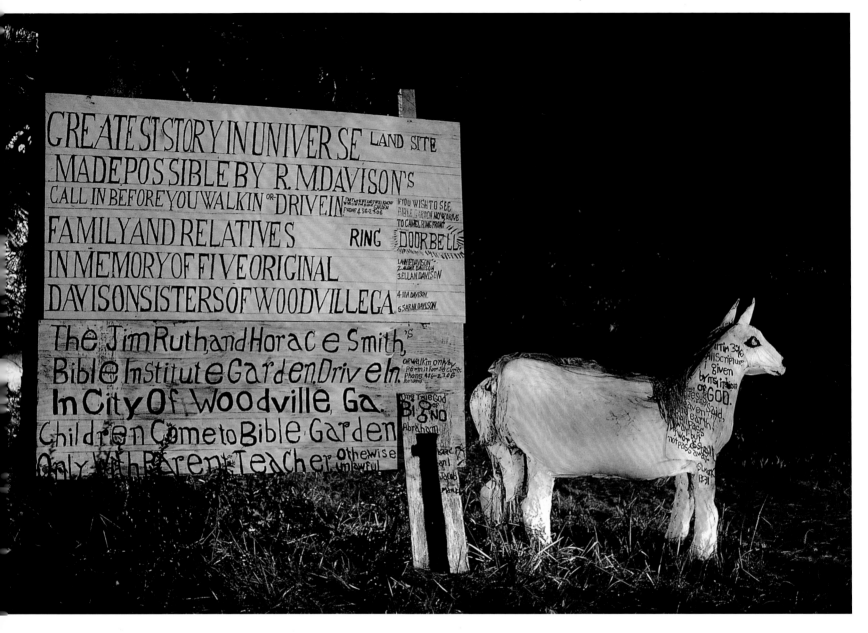

Reverend John D. Ruth

Born in Woodville, Georgia, 1914.
Died in Woodville, Georgia, 1995.

Ruth, a college graduate, worked as a musician in Athens, Georgia, until 1954, when he had a visionary experience in which, he claims, God came to him and stated, "John D. Ruth will work." Ruth then dedicated his life to God and to teaching the word of the Bible. Returning to Woodville, he became the pastor of the community Pentecostal Church. He also began work on the sculptural environment he called the Bible Garden.

Ruth's twenty-acre garden was filled with statues and paintings. Constructed from cement, wood panels, papier-mâché, and various found objects, the pieces were painted and covered with messages that illustrated stories and teachings from the Bible. The Bible Garden attracted visitors from all over the United States. Despite his popularity, Ruth never sold his art. After he died, the Bible Garden was dismantled.

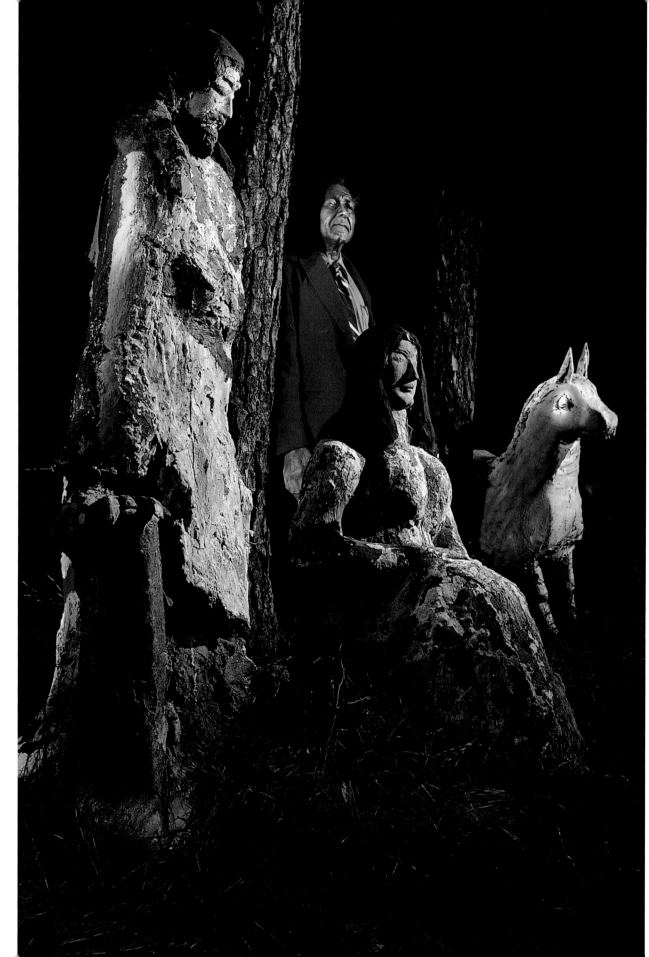

<
Sign and sculpture,
cement and house
paint construction

Cement sculptures,
cement and house
paint construction

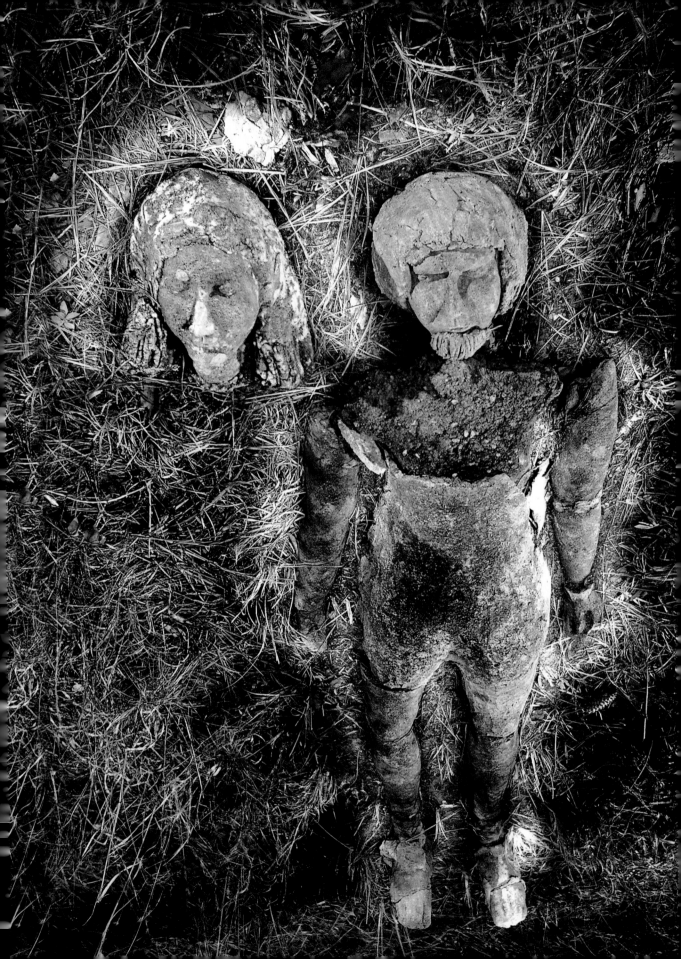

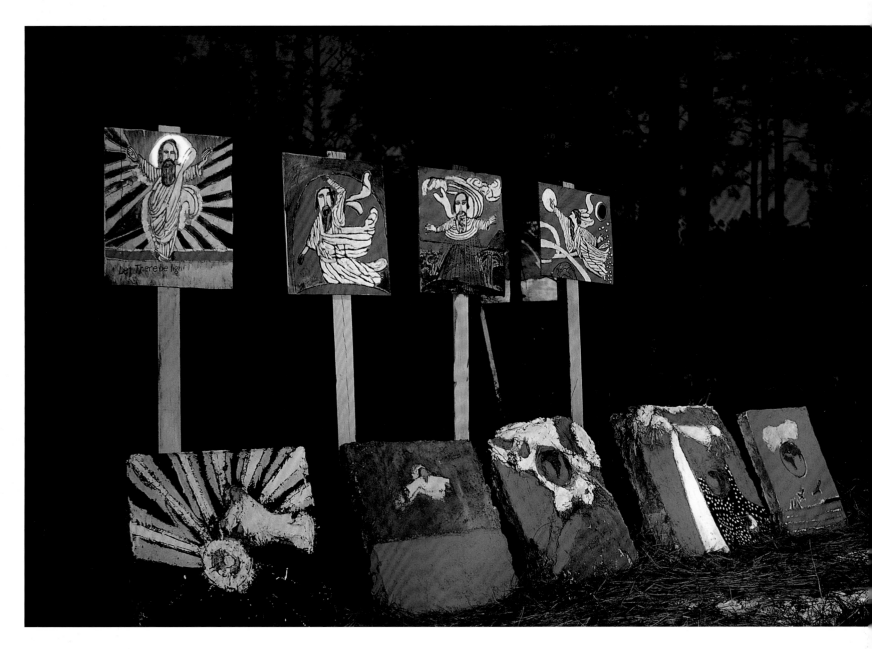

< Cement sculptures,
cement and mixed
media construction

Yard signs, house
paint on wood

Earl Simmons

I always made art—as a child, I made art. There was no real reason I started all this. It just came natural. Sometimes you have to work real hard for things. Sometimes it takes a long time until those things pay off. I just thank God for what I have. I thank God for my good talent.

Born in Bovina, Mississippi, 1956. Resides in Bovina, Mississippi.

Simmons attended school through the eighth grade and then worked at odd jobs in Bovina. He later moved to Quantico, Virginia, where he joined the Job Corps. On his return to Bovina, Simmons took a job running the machinery in a lumber mill, and then went to work for the highway department, where he is currently employed. He started construction of his "art shop," a hand-crafted roadside gallery filled with his creations.

Primarily a sculptor, Simmons works with cast-off pieces of wood, sheet metal, plastic, rubber, and other found materials, which he nails together. He makes jukeboxes, cars, airplanes, trucks, buildings, and animal figures. His work has been commissioned in both the private and public sectors and is represented in various galleries and museum collections.

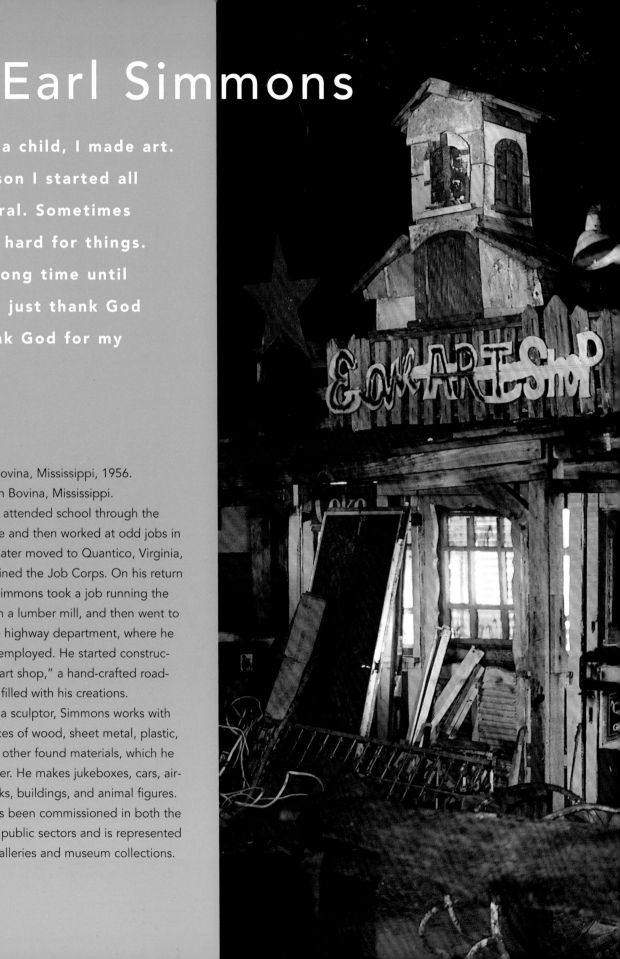

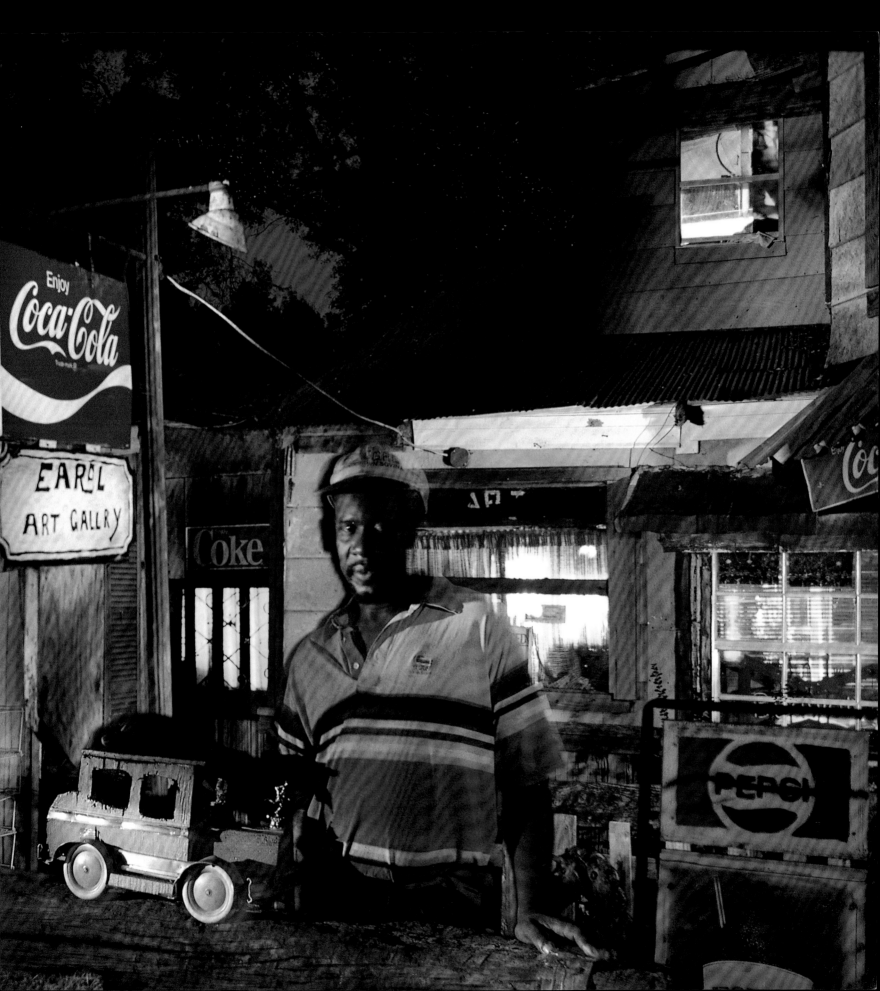

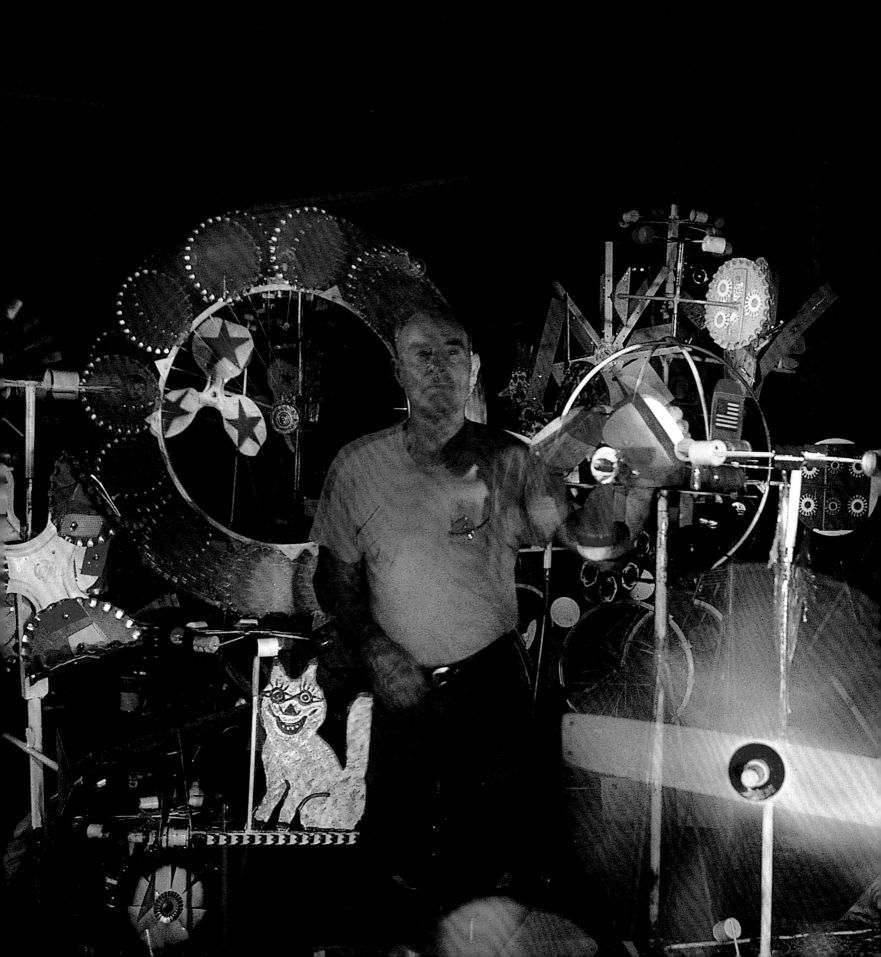

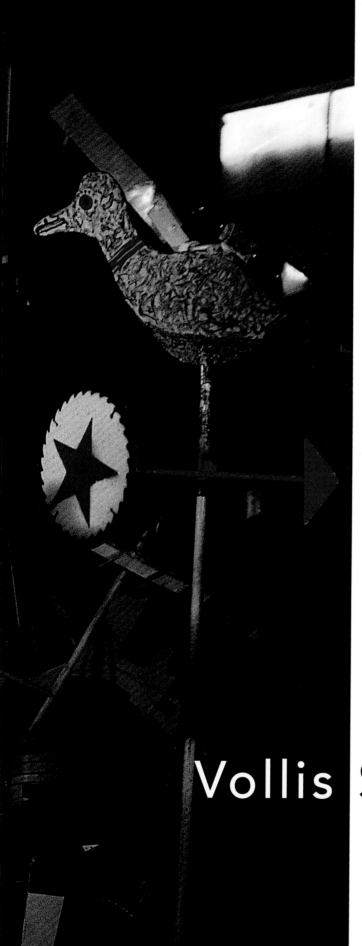

I built my first whirligig to power a washing machine while stationed in Saipan [in the Mariana Islands] during World War II. Later I had a machine repair shop. I spent years working on all kinds of farm and tobacco machines. I even built my own parts. I also had a house-moving business. I learned a lot about balance and adapting machinery during those years.

I want to capture the wind's moving force. It's a thing of beauty. When people call my work art, I think to myself, Oh, I don't know—I just feel "wore out." I've enjoyed making all the pieces and putting them together, but I probably should have started a little earlier in life. Time is running out. I guess when I die somebody can take all of my stuff and have a large yard sale.

Vollis Simpson

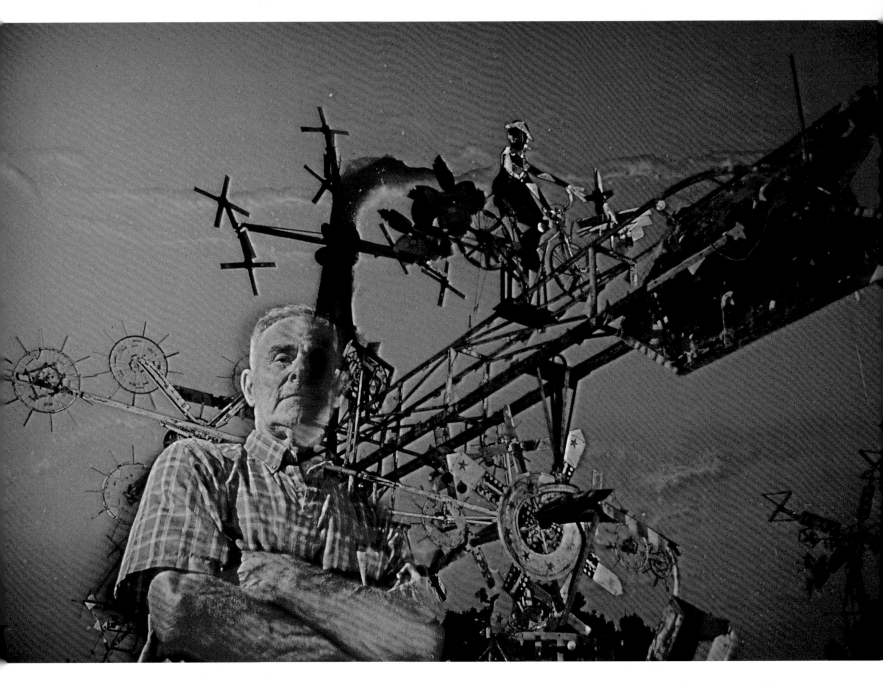

Vollis Simpson

Born in Lucama, North Carolina, 1919. Resides in Lucama, North Carolina.

Simpson worked on the family farm until he was drafted into the army in 1941. Stationed on the island of Saipan in the western Pacific Ocean, he built his first windmill. When World War II was over, he opened his own tractor and truck repair shop near Williams, North Carolina. In 1969 he began working on the sculptural environment that now occupies over an acre of his land.

Using plywood, tractor enamel, and spare iron and steel parts left over from his repair shop, Simpson creates sophisticated windmills or whirligigs that stand up to forty feet high. Visitors from all around the country have come to see these brightly colored, moving objects. Simpson's work has been displayed at the North Carolina Museum of Art in Raleigh and the High Museum of Art in Atlanta, Georgia.

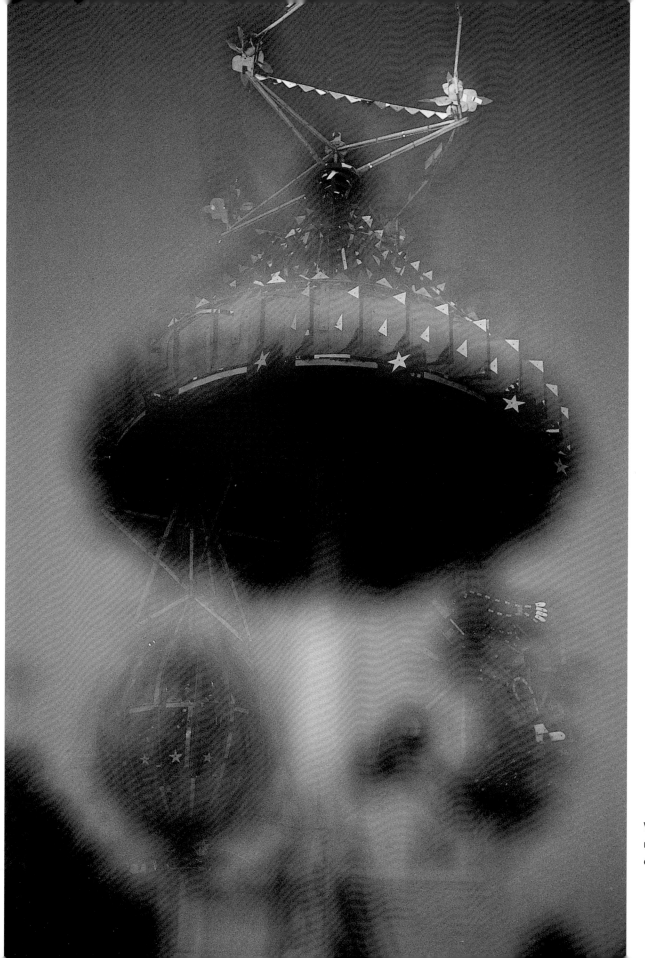

Whirligigs, mixed
media mechanical
construction

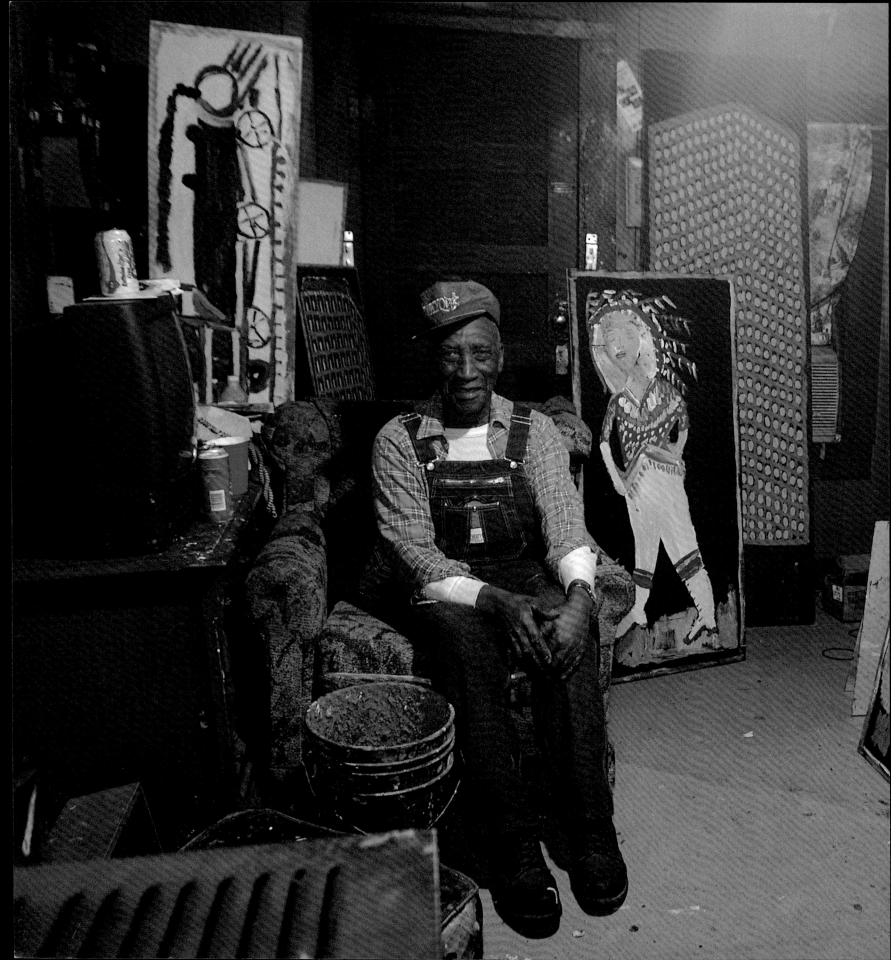

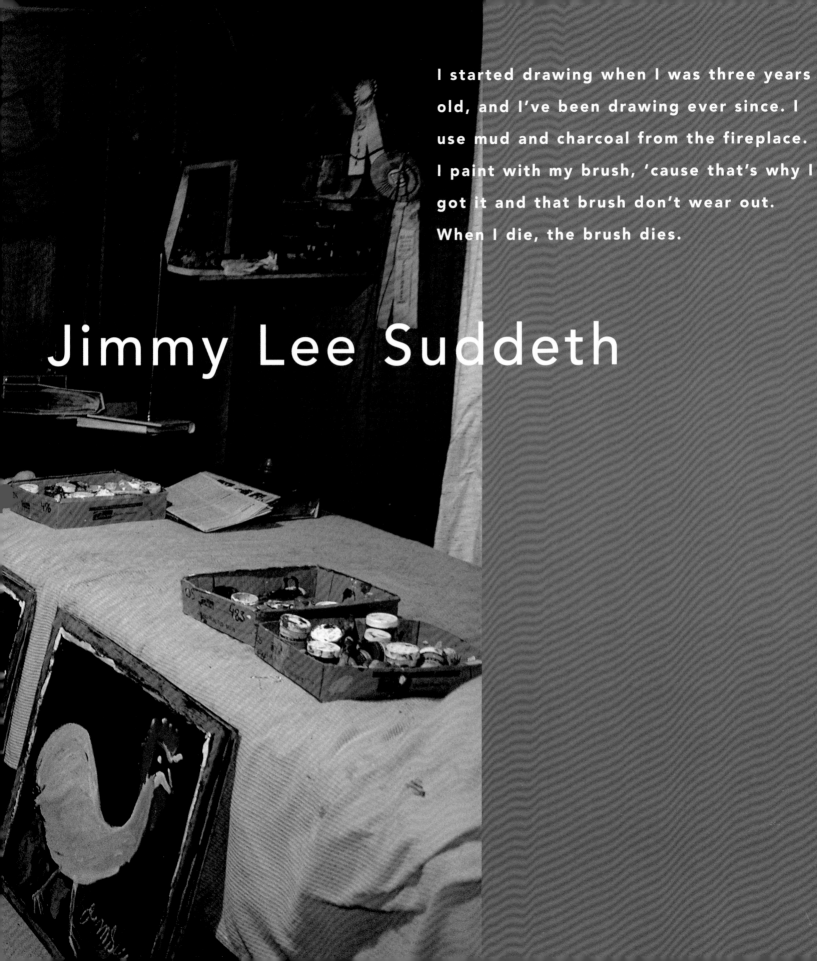

I started drawing when I was three years old, and I've been drawing ever since. I use mud and charcoal from the fireplace. I paint with my brush, 'cause that's why I got it and that brush don't wear out. When I die, the brush dies.

Jimmy Lee Suddeth

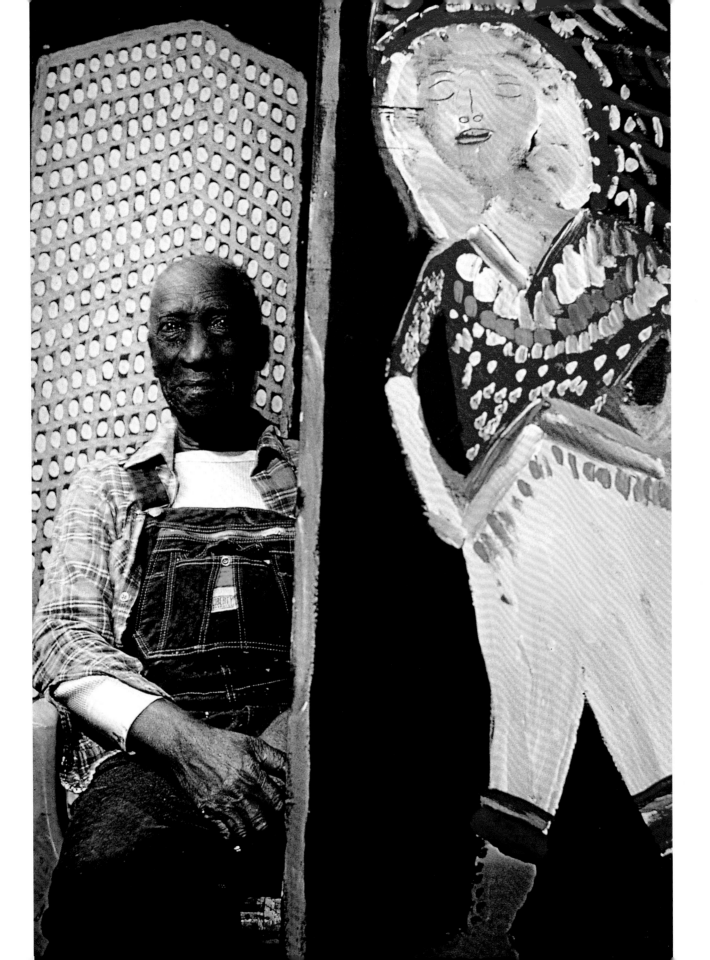

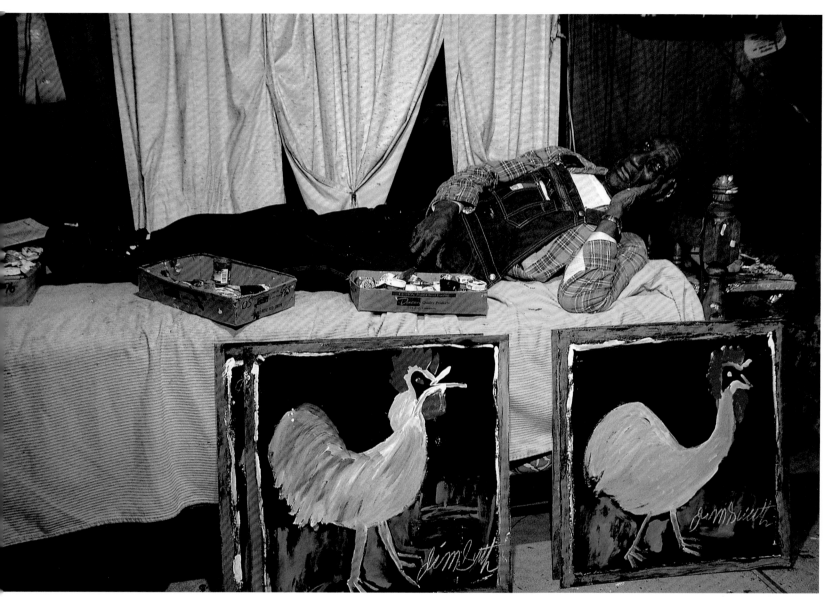

Jimmy Lee Suddeth

Born in Caines Ridge, Alabama, 1910. Resides in Fayette, Alabama.

Suddeth, who has been painting all his life, had little formal education and was employed as a farmer and mill worker for most of his youth. In the early 1950s he and his wife, Ethel Palmore, moved to Fayette, where Suddeth worked as a gardener and occasionally at other odd jobs.

Suddeth paints with a mixture of mud and sugar which he keeps in a galvanized bucket. The sweetwater, as he calls it, makes the paint permanent. Using mainly plywood as a palette, Suddeth renders images of animals, cars, and various architectural structures. In 1971 the paintings were first displayed to the public at the Fayette Art Museum. Suddeth gained further recognition as an artist in 1976 when he was a participant in the bicentennial Festival of American Folk Life in Washington, D. C., and in 1980 with an appearance on the *Today* show. He continues to paint daily at his home.

Willie Tarver

I have a gift for seeing something, and, after I see anything, I can just make that. And I see all kinds of things—what some people may call weird, some people call foresight, or photographic memory, all that. But I can see something, an object or person and I can make that out of cement or with the welding machine.

I got into all this from messin' around with cement, trying to make a gravestone for my brother years ago. Then I started making the work for myself. I have always liked statues. I wanted to have a lot of statues around. Now my whole yard is full of statues.

Willie and Mae Tarver

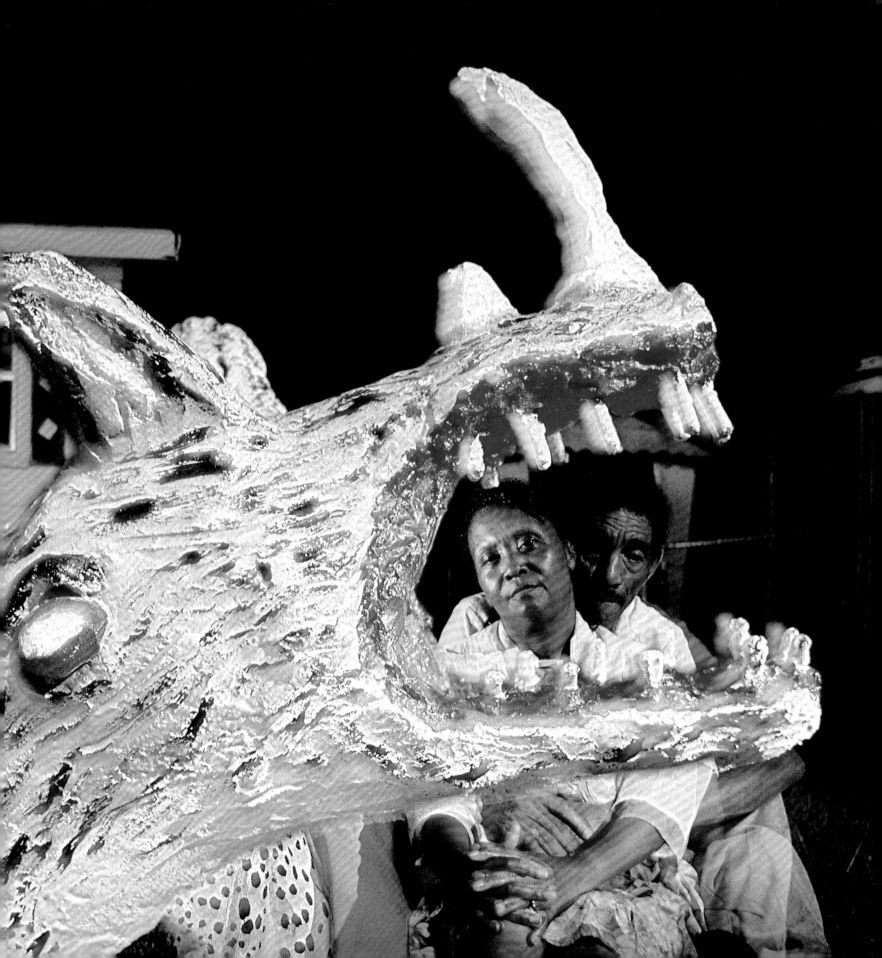

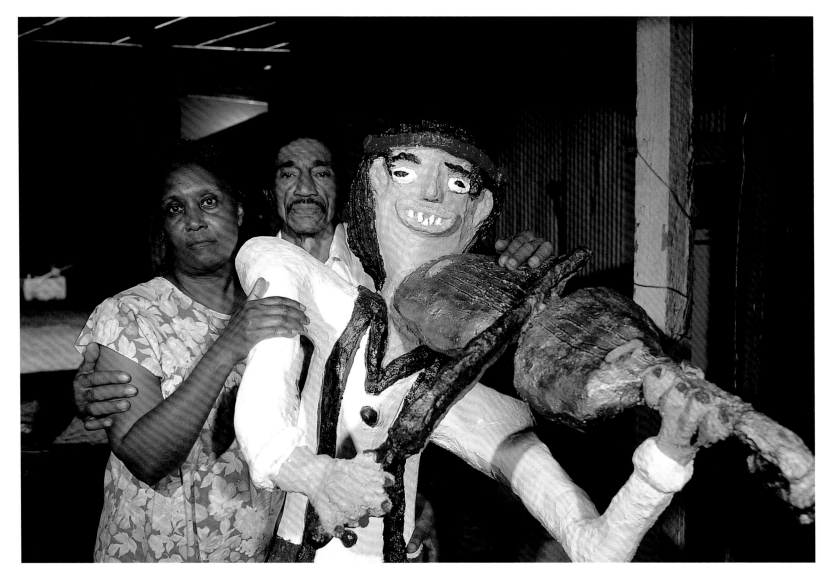

Willie Tarver

Born in Bartow, Georgia, 1932.
Resides in Watley, Georgia.

Tarver grew up in rural Georgia, attending school through the sixth grade in a one-room schoolhouse. As a young adult, he worked with his father sharecropping, and he later took a job in a lumberyard. At the beginning of the Korean War, Tarver was drafted into the army. When the war was over, he moved to New York to pursue his childhood sweetheart, Mae, whom he soon married. Tarver later returned to the South, where he worked repairing refrigerators for twenty-five years until he retired.

Made of cement and cast-off pieces of metal, Tarver's many sculptures lie scattered about, decorating his property. Created primarily for himself, these sculptures have rarely been seen beyond his own home.

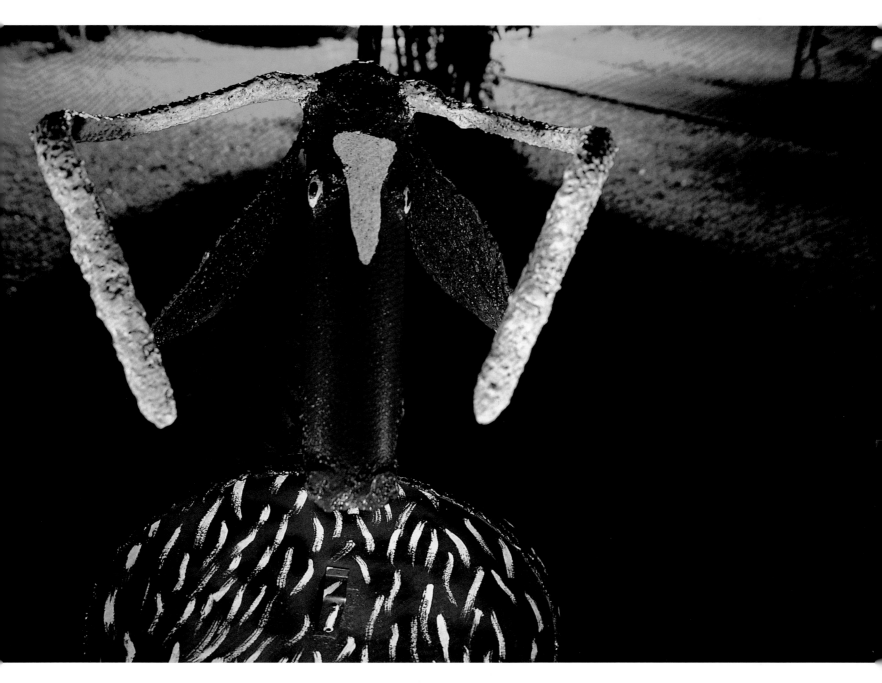

Sculpture, cement,
metal, mixed media
construction

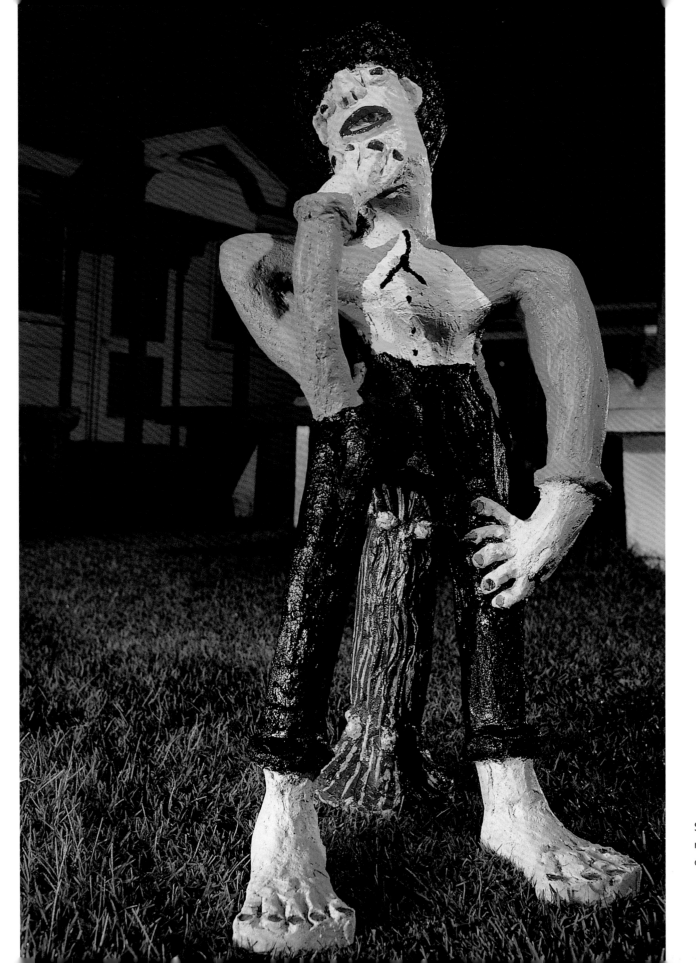

Sculpture, cement,
metal, mixed media
construction

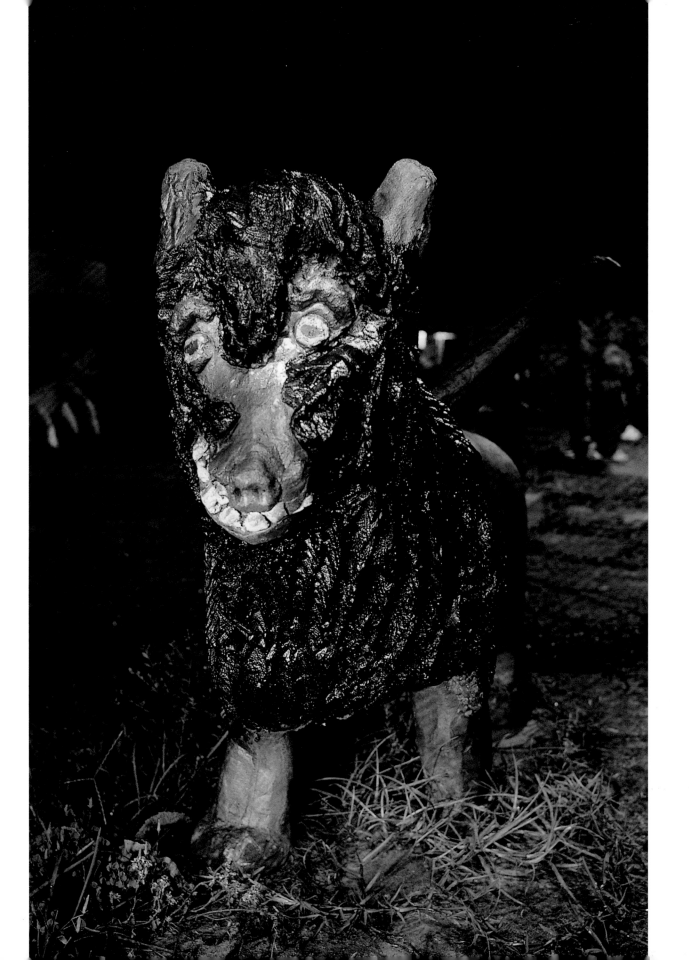

Sculpture, cement,
metal, mixed media
construction

I love to paint because my paintings
are beautiful. The president told me so.

Mose Tolliver

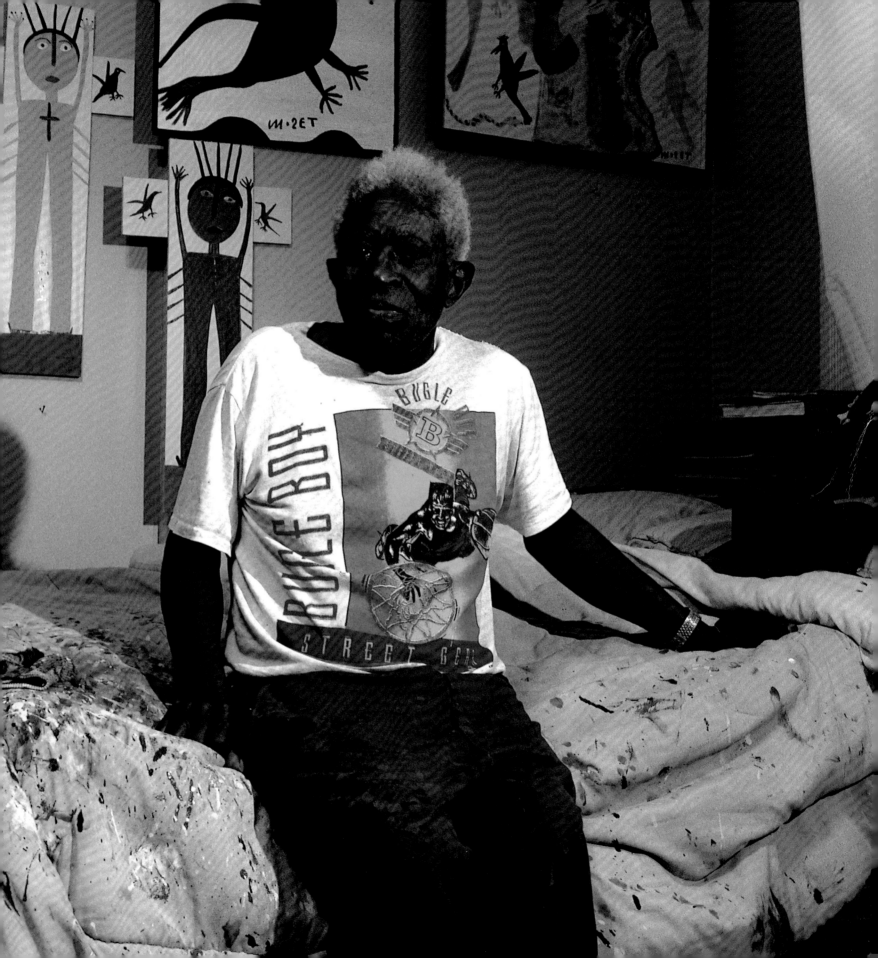

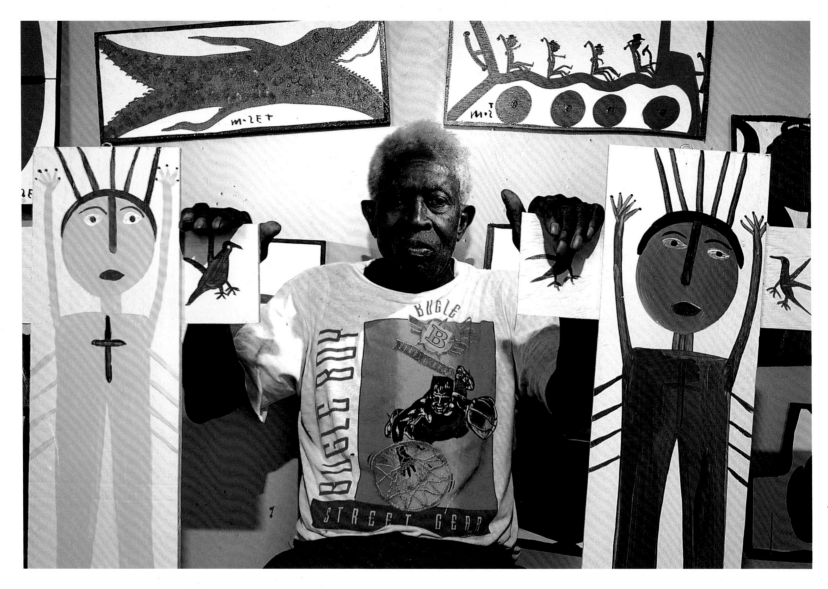

Mose Tolliver

Born in Pike Road Community,
 Alabama, 1919.
Resides in Montgomery, Alabama.

Early in his life, Tolliver labored as a tenant farmer and gardener outside of Montgomery, Alabama. He later found employment at the McLendon Furniture Company, where a load of marble crushed his legs, leaving him partially crippled and unable to work. He began to paint in the early 1970s. Working on plywood and using house paint, Tolliver lives out various fantasies in his art. He creates fantastic animals and creatures, still lifes of various objects, and many sexually charged images of women with legs spread positioned above pointed objects Tolliver calls "exercising bicycles" or "scooters." He also paints many self-portraits—figures perched on crutches.

Tolliver's home is a virtual museum of his own work, with art covering every wall and doorway in the house. Visited by collectors and fans from all over the country, Tolliver is one of the most recognized folk artists in the southern United States.